Pro·Lighting

ALEX LARG and JANE WOOD

BLACK AND WHITE SHOTS

RotoVision

A RotoVision Book

Published and Distributed by RotoVision SA
Rue Du Bugnon 7
CH-1299 Crans-Près-Céligny
Switzerland

RotoVision SA, Sales & Production Office
Sheridan House, 112/116A Western Road
Hove, East Sussex, BN3 1DD, UK
Tel: +44 (0) 1273 72 72 68
Fax: +44 (0) 1273 72 72 69
e-mail: sales@RotoVision.com

Distributed to the trade in the United States by:
Watson-Guptill Publications
1515 Broadway
New York, NY 10036
USA

1 3 5 7 9 10 8 6 4 2

ISBN: 2-88046-462-5

Book design by
Design Revolution Ltd

Production and separations in Singapore by
ProVision Pte. Ltd.
Tel: +65 334 7720
Fax: +65 334 7721

CONTENTS

THE PRO-LIGHTING SERIES

The most common response from the photographers who contributed to this book, when the concept was explained to them, was "I'd buy that". The aim is simple: to create a library of books, illustrated with first-class photography from all around the world, which show exactly how each individual photograph in each book was lit.

Who will find it useful? Professional photographers, obviously, who are either working in a given field or want to move into a new field. Students, too, who will find that it gives them access to a very much greater range of ideas and inspiration than even the best college can hope to present. Art directors and others in the visual arts will find it a useful reference book, both for ideas and as a means of explaining to photographers exactly what they want done. It will also help them to understand what the photographers are saying to them. And, of course, "pro/am" photographers who are on the cusp between amateur photography and earning money with their cameras will find it invaluable: it shows both the standards that are required, and the means of achieving them.

The lighting set-ups in each book vary widely, and embrace many different types of light source: electronic flash, tungsten, HMIs, and light brushes, sometimes mixed with daylight, flames and all kinds of other things. Some are very complex; others are very simple. This variety is very important, both as a source of ideas and inspiration and because each book as a whole has no axe to grind: there is no editorial bias towards one kind of lighting or another, because the pictures were chosen on the basis of impact and (occasionally) on the basis of technical

difficulty. Certain subjects are, after all, notoriously difficult to light and can present a challenge even to experienced photographers. Only after the picture selection had been made was there any attempt to understand the lighting set-up.

This book is a part of the sixth series: BLACK & WHITE SHOTS and PROVOCATIVE SHOTS. Previous titles in the series include EROTICA, FASHION SHOTS, NEW PRODUCT SHOTS, INTERIOR SHOTS, GLAMOUR SHOTS, SPECIAL EFFECTS, NUDES, PRODUCT SHOTS, STILL LIFE, FOOD SHOTS, LINGERIE SHOTS, PORTRAITS, BEAUTY SHOTS, NIGHT SHOTS and NEW GLAMOUR. The intriguing thing in all of them is to see the degree of underlying similarity and diversity to be found in a single discipline or genre.

Black and White Shots features a wide range of images including people, portraits, commercial fashion and advertising shots, as well as still life, fine art and nudes. A selection of shots have been included to demonstrate ways of elaborating the classic black and white look by means of tinting and toning the image.

Provocative Shots features a wide range of erotic imagery from the 'fine art' look to the blatant fetish end of the spectrum. The commercial possibilities for provocative shots are

many and varied but it is no surprise that many photographers experiment in this area too, and the shots featured include the imaginative extremes of this experimental output.

The structure of the books is straightforward. After this initial introduction, which changes little among all the books in the series, there is a brief guide and glossary of lighting terms. Then, there is specific introduction to the individual area or areas of photography which are covered by the book. Sub-divisions of each discipline are arranged in chapters, inevitably with a degree of overlap, and each chapter has its own introduction. Finally, there is a directory of those photographers who have contributed work.

If you would like your work to be considered for inclusion in future books, please write to RotoVision SA, Sheridan House, 112–116A Western Road, Hove, East Sussex, BN3 1DD, UK. DO NOT SEND PICTURES, either with the initial inquiry or with any subsequent correspondence, unless requested; unsolicited pictures may not always be returned. When a book is planned which corresponds with your particular area of expertise, we will contact you. Until then, we hope that you enjoy this book; that you will find it useful; and that it helps you in your work.

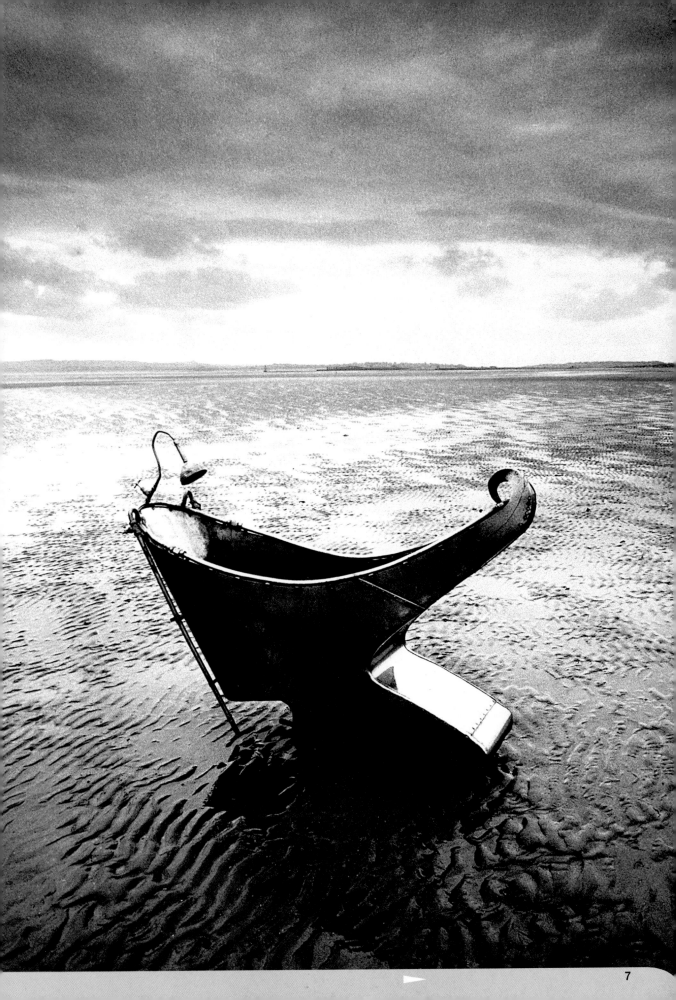

HOW TO USE THIS BOOK

The lighting drawings in this book are intended as a guide to the lighting set-up rather than as absolutely accurate diagrams. Part of this is due to the variation in the photographers' own drawings, but part of it is also due to the need to represent complex set-ups in a way which would not be needlessly confusing.

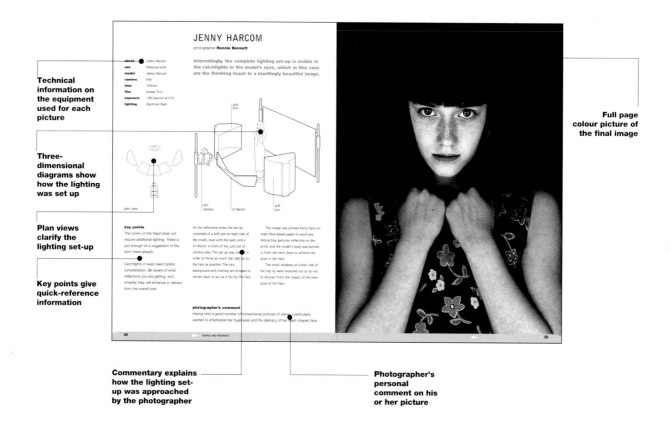

Technical information on the equipment used for each picture

Three-dimensional diagrams show how the lighting was set up

Plan views clarify the lighting set-up

Key points give quick-reference information

Full page colour picture of the final image

Commentary explains how the lighting set-up was approached by the photographer

Photographer's personal comment on his or her picture

Distances and even sizes have been compressed and expanded: and because of the vast variety of sizes of soft boxes, reflectors, bounces and the like, we have settled on a limited range of conventionalised symbols. Sometimes, too, we have reduced the size of big bounces, just to simplify the drawing.

None of this should really matter, however. After all, no photographer works strictly according to rules and preconceptions: there is always room to move this light a little to the left or right, to move that light closer or

further away, and so forth, according to the needs of the shot. Likewise, the precise power of the individual lighting heads or (more important) the lighting ratios are not always given; but again, this is something which can be "fine-tuned" by any photographer wishing to reproduce the lighting set-ups in here.

We are, however, confident that there is more than enough information given about every single shot to merit its inclusion in the book: as well as purely lighting techniques, there are also all kinds of hints and tips about commercial realities, photographic

practicalities, and the way of the world in general.

The book can therefore be used in a number of ways. The most basic, and perhaps the most useful for the beginner, is to study all the technical information concerning a picture which he or she particularly admires, together with the lighting diagrams, and to try to duplicate that shot as far as possible with the equipment available.

A more advanced use for the book is as a problem solver for difficulties you have already encountered: a

particular technique of back-lighting, say, or of creating a feeling of light and space. And, of course, it can always be used simply as a source of inspiration.

The information for each picture follows the same plan, though some individual headings may be omitted if they were irrelevant or unavailable. The photographer is credited first, then the client, together with the use for which the picture was taken. Next come the other members of the team who worked on the picture: stylists, models, art directors, whoever. Camera and lens come next, followed by film. With film, we have named brands and types, because different films have very different ways of rendering colours and tonal values. Exposure comes next: where the lighting is electronic flash, only the aperture is given, as illumination is of course independent of shutter speed. Next, the lighting equipment is briefly summarised — whether tungsten or flash, and what sort of heads — and finally there is a brief note on props and backgrounds. Often, this last will be obvious from the picture, but in other cases you may be surprised at what has been pressed into service, and how different it looks from its normal role.

The most important part of the book is however the pictures themselves. By studying these, and referring to the lighting diagrams and the text as necessary, you can work out how they were done; and showing how things are done is the brief to which the Pro-Lighting series was created.

DIAGRAM KEY

The following is a key to the symbols used in the three-dimensional and plan view diagrams. All commonly used elements such as standard heads, reflectors etc., are listed. Any special or unusual elements involved will be shown on the relevant diagrams themselves.

THREE-DIMENSIONAL DIAGRAMS

large format camera

medium format camera

35mm camera

standard head

standard head with barn doors

spot

strip

soft box

light brush

reflector/diffuser/bounce

table

backdrop

PLAN VIEW DIAGRAMS

large format camera

medium format camera

35mm camera

bounce

gobo

diffuser

reflector

standard head

standard head with barn doors

spot

strip

soft box

light brush

backdrop

table

GLOSSARY OF LIGHTING TERMS

Lighting, like any other craft, has its own jargon and slang. Unfortunately, the different terms are not very well standardised, and often the same thing may be described in two or more ways or the same word may be used to mean two or more different things. For example, a sheet of black card, wood, metal or other material which is used to control reflections or shadows may be called a flag, a French flag, a donkey or a gobo – though some people would reserve the term "gobo" for a flag with holes in it, which is also known as a cookie. In this book, we have tried to standardise terms as far as possible. For clarity, a glossary is given below.

LIGHTS AND STANDS

Boom

Extension arm allowing a light to be cantilevered out over a subject.

Effects light

Neither key nor fill; a small light, usually a spot, used to light a particular part of the subject. A hair-light on a model is an example of an effects (or "FX") light.

Fish fryer

A small soft box.

Flash head

see Head

Fluorescent lighting

A non-incandescent source with a discontinuous colour temperature but a cool physical temperature (cool to the touch). However, fluorescent heads are now available which offer control of the colour temperature to give a flicker-free continuous light.

Head

Light source, whether continuous or flash. A "standard head" is fitted with a plain reflector. A

Electronic flash: Monoblock (Elinchrom)

Powerpack (Elinchrom)

head with built-in power supply and setting controls is called a Monoblock (as opposed to a head which has to be plugged into a remote power pack/control panel).

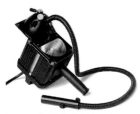

Electronic flash: light brush "pencil" (Hensel)

Electronic flash: light brush "hose" (Hensel)

HMI

Rapidly-pulsed and effectively continuous light source approximating to daylight and running far cooler than tungsten.

Incandescent lighting

see Tungsten

Light brush

A light source "piped" through a fibre-optic lead. Can be used to add highlights, delete shadows and modify lighting, literally by "painting with light".

Monoblock

see Head

Pantograph

A suspension device for positioning lights by means of extendable concertina construction. Can be motorised for easy control.

Electronic flash: soft box (Elinchrom)

Electronic flash: octabox (Elinchrom)

Projection spot

Flash or tungsten head with projection optics for casting a clear image of a gobo or cookie. Used to create textured lighting effects and shadows.

Ring flash

A circular flash tube placed around the camera lens. Gives distinctive circular catchlights and typically a shadowless shot.

Electronic flash: strip light with removable barn doors (strobes)

Soft box

Large, diffuse light source made by shining a light through one or two layers of diffuser. Soft boxes come in many shapes (for example,

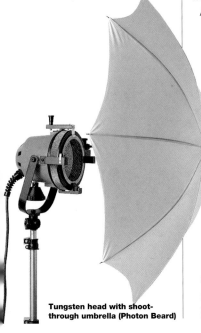

Tungsten head with shoot-through umbrella (Photon Beard)

octagonal, strip, and full-length rectangular boxes) and many sizes (from about 30x30cm to 120x180cm and larger). Some soft boxes are rigid; others are made of fabric stiffened with poles resembling fibreglass fishing rods. Also known as a northlight or window light, though these can also be created by shining standard heads through large diffusers.

Standard head

see Head

Strip or strip light

see Soft box

Tungsten

Incandescent lighting. Photographic tungsten runs at 3200 °K or 3400 °K, as compared with domestic lamps which run at 2400–2800 °K.

UV
(ultra-violet or "black light")

Light with wavelengths of less than about 390nm.

Window light

Apart from the obvious meaning of light through a window, or of light shone through a diffuser to look as if it is coming through a window, this is another name for a soft box.

REFLECTORS AND FLAGS

Acrylic sheeting

Hard, shiny plastic sheeting, usually methyl methacrylate, used as a diffuser ("opal") or in a range of colours as a background.

Bounce

A passive reflector, typically white (but also available in, for example, silver and gold), from which light is bounced back on to the subject. Also used in the compound term "Black bounce", meaning a flag used to absorb light rather than to create a shadow.

Flag

A rigid sheet of metal, board, foam-core or other material used to absorb light or to create a shadow. Many flags are black on one side and white or silver on the other so that they can be used either as flags or reflectors. To "flag" means to control where the light falls (e.g. to control spill or to prevent flare). A French flag is mounted on the camera itself.

Flat

A large bounce, often made of a thick sheet of expanded polystyrene or foam-core (for lightness).

Kill spill

A large flat used to block spill.

Mirror

Exactly what its name suggests. The only reason for mentioning it here is that reflectors are rarely mirrors, because mirrors focus light and create "hot spots" while reflectors diffuse light. Mirrors (especially, for example, small shaving mirrors) are, however,

widely used, almost in the same way as effects lights.

Umbrella

Exactly what its name suggests. Umbrellas may be used as reflectors (with the light shining into the umbrella; they are available in silver and gold as well as white) or as diffusers (with the light shining through the umbrella). The cheapest way of creating a large, soft light source.

MODIFIERS

Acetate

see Gel

Barn doors

Adjustable flaps affixed to a lighting head to shade light from a particular part of the subject.

Barn doors

Cookie

see Gobo

Diffuser

Translucent material used to diffuse light. Includes tracing paper, frost, scrim, umbrellas, translucent plastics such as Perspex and Plexiglass, and more.

Gel

Transparent or (more rarely) translucent

coloured material used to modify the colour of a light. It is an abbreviation of "gelatine (filter)", though most modern gels for lighting use are actually made of acetate.

Gobo

As used in this book, synonymous with cookie: a flag with cut-outs, to cast interestingly shaped shadows; also used in projection spots.

"cookies" or "gobos" for projection spotlight (Photon Beard)

Honeycomb

Grid of open-ended hexagonal cells, closely resembling a honeycomb. Increases the directionality of light from any head.

Scrim

Heat-resistant diffuser used to soften lighting.

Honeycomb (Hensel)

Snoot

Conical restrictor, fitting over a lighting head. The light can only escape from the small hole in the end and is therefore very directional.

Tungsten head with conical snoot (Photon Beard)

TERMINOLOGY

Black light

Another name for UV (ultra-violet) light.

Continuous lighting

What its name suggests: light which shines continuously rather than being a brief flash.

Contrast

see Lighting ratio

Fill

Extra light, either from a separate head or from a reflector which "fills" the shadows and lowers the lighting ratio.

Fresnel

Ridged lens for use on lighting heads. Key or key light. The dominant or principal light; the light that casts the shadows.

Lastolite

Company name, commonly used to mean the flexible, portable reflectors that they manufacture.

Lighting ratio

The ratio of the key to the fill, as measured by an incident light meter. A high lighting ratio (8:1 or above) is very contrasty, especially in colour; a low lighting ration (4:1 or less) is flatter or softer. A 1:1 lighting ratio is completely even all over the subject.

Modelling

Graduated shadows over a curved surface giving a strong impression of its three-dimensional form.

Perspex

Brand name for acrylic sheeting.

Plexiglass

Brand name for acrylic sheeting.

Spill

Light from any source which ends up other than on the subject at which it is pointed. Spill may be used to provide fill or to light background, or it may be controlled with flags, barn doors, gobos etc.

Spot

Directional light source. Normally refers to a light using a focusing system with reflectors or lenses or both (known as a "focusing spot") but also loosely used as a reflector head rendered more directional with a honeycomb.

Swimming pool

A very large soft box.

Tungsten head with safety mesh (behind) and wirehalf diffuser scrim (Photon Beard)

WHY BLACK AND WHITE?

There are many answers. One of the most commonly cited is difficult to define, because it is essentially an emotional response to black and white shots. Descriptions of it tend to centre on words such as "mood" and "atmosphere". Many people would agree that black and white film captures a certain "atmosphere" or "mood" that somehow often eludes a colour shot of the same subject. There does seem to be, for many people, a definite poignancy to many successful black and white shots. Sometimes this stems from a gentleness to the lighting and tone, sometimes from a contrasting harshness, but always the best black and white shots have an evocative, emotive quality that is difficult to define but impossible to deny.

Perhaps it is the very lack of colour, and the resulting "distancing" of the image from our everyday colour-filled lives, that makes these images transcend our mundane everyday experience and become something more remote, mystical and universal. Hence the appeal, the perception that there is some greater truth, an emotional and almost spiritual dimension to black and white images.

It is difficult to trace where this evocativeness comes from; where our "belief" in black and white photographs emanates from. Perhaps it is to do with the way in which black and white images can evoke a sense of the earliest photographs, and make us feel some sense of continuity and connection with those historical images and experiences. Or perhaps it is to do with the long-term traditional uses of black and white images, a tradition that continues to inform our responses to black and white

images considerably. Often we associate black and white shots with journalistic and documentary subjects, simply because historically the newspapers and magazines that purveyed such images have, on the whole, been mainly in black and white. We therefore associate such documentary black and white shots with "fact", in that they depict things, people and places as they really are at the moment the shot is taken.

But we have also learned to believe that such images show "the truth" in a wider sense, and this historical association between "great truths" and black and white photographs persists. For example, Dorothea Lange's well-known shot of a mother and her children during the Great Depression was not just about the individuals in the picture; it was about poverty, the Great Depression, politics, class, and so on. Similarly the world-famous image of the little girl fleeing with napalm burning her

skin will forever speak volumes about war, suffering and human nature in general. Perhaps because of our embedded belief that documentary and journalistic (i.e. black and white) images tell the truth, we are tempted to read larger truths into other types of black and white image. The "great truth" factor persists, and we interpret our emotional response to this as evidence of an intrinsic quality to the medium.

To move on to a more prosaic level, an alternative answer to the question "Why black and white?" might focus on technical qualities such as grain, tone, line, form and texture. All these qualities are possible in a colour shot, but black and white relies more directly on successful deployment of graphic form, and has a tendency to emphasise elements such as texture of subject and grain texture of the film and/or print. The monochrome image is akin to the artist's pencil

drawing, where colour as a consideration is left aside and full attention is given to form, texture, composition, shading and other such structural considerations.

Colour can be applied in the form of tinting selected areas of an image by hand, or by toning the whole of an image, either via choice of film stock and processing, or at the printing stage. But such colour application tends to have a restrained air, and is often used for particular subtle effects or to enhance a particular mood. Again, historical association is very powerful. Sepia-toned images have an inescapable historical timbre, and modern-day images can acquire a specifically ancient look if sepia is used appropriately (as in the case of Ron P. Jaffe's portrait "Iron Eyes Cody", for example, where a subject with historical resonance is shot in a historically evocative way). The aesthetic and artistic possibilities intrinsic to black and white stock and the numerous printing and finishing techniques represent a compelling range of reasons as to why many photographers still choose to work extensively in black and white.

Films for black and white

There is a surprisingly wide range of stocks available for the photographer who wants to explore the possibilities of black and white photography, though not necessarily in all formats. At the conservative end of the spectrum are what might be considered as "standard" black and white stocks – basic staple stocks such as Tmax 100 or Ilford FP4 Plus, which give a good, reliable tonal range, excellent grain structure and are widely and readily available. Also widely available are chromogenic film stocks such as Ilford XP2 and Kodak Tmax 400CN – black and white effect films that can be developed inexpensively through standard laboratory C41 processing. These chromogenic films can also be cross-processed to monochrome transparencies.

At the more specialist end of the spectrum come the stocks that offer particular distinctive qualities to the photographer. These include such stocks as Kodak Infra-red, Konica Infra-red and Ilford SFX 200, which each have their own characteristic look. It is important to be aware of issues such as ratings in relation to films of these types. Kodak infra-red, for example, does not have an ascribed ISO and the photographer needs to be aware of the range of results possible by selecting various ratings. (Of course, it is true of all stocks that ISO rating can be variable depending on what developer is used and whether a high-contrast or low-contrast negative is required.) The typical infra-red look is an unearthly glow with unfamiliar distribution of tone and areas of light and dark. The chlorophyll of green vegetation reflects a great deal of infra-red and so this makes leaves register as areas of glowing light. Eyes, however, reflect very little infra-red, so they typically register with a velvety, and somewhat eerie, rich darkness.

For a quite different but equally interesting look, Tmax 400 offers what is described as a tessellating grain. Some photographers adopt particular stocks as a type of trademark look for their work, and in this book, this kind of photographer-film relationship is demonstrated by the two shots by Gérard de Saint-Maxent using his oft-favoured choice of Tmax 400. His shots "L'intimé" and "Diamonds" demonstrate what can be achieved by getting to know a stock intimately, and developing a style that uses the film's possibilities to the utmost. These shots represent classic Saint-Maxent.

The majority of black and white film stocks produce negatives and there has been a gap in the market for some time for transparency-producing stocks. Agfa Scala is

worth exploring for those interested in the relatively unusual format of a black and white transparency. Also worth exploring is Polaroid Polapan, which can be developed on the spot in a specialist portable processor, if only for the sheer exhilaration of seeing the strip of transparencies emerge from the cassette merely minutes after shooting the film. Also exciting is Polaroid Polagraph, the glistening transparencies (and the unique quality of prints taken from them) are a joy to see, though handle with care, since they are delicate and the emulsion can be easily damaged.

Ultra high-speed films, such as Kodak Tmax 3200 and Ilford Delta 3200, are nowadays far less grainy than the equivalent stocks that used to be available, which means that they can be used in lower levels of light, and therefore, in a greater diversity of situations.

Cameras and filters

Not all film stocks are available for all formats, so if the photographer has a particular wish to use a particular stock, this may determine what camera format can be used. Otherwise, there are no intrinsic restrictions to working with black and white on choice of camera. It is true with black and white as with colour that a larger format will

always help to record good detail in dark areas and really see into the shadows, so if a shot is planned where this is an issue, and the black and white shot is going to be more black than white, then a medium or large format camera may be the natural preference. Similarly, the larger the negative, the sharper, potentially, the printed image (because less enlarging is required subsequently). Again, this may or may not be a consideration for a particular image.

Filters may be required to adjust and control contrast levels in some situations. A red filter will enhance the dramatic contrast of clouds in a bright sky, for example, by absorbing blue light from the sky and making it appear darker, causing the clouds to appear relatively bright. Orange and yellow filters serve a similar purpose, but to a lesser extent in each case. Less commonly used is the green filter, which will have a different effect again, and it is worth experimenting to compare results. Typically, a green filter used on, say, a green grass subject, will render greater detail in foliage than might otherwise be the case, or may darken sky, and so on. As for colour shots, a polarising filter is also useful to have to hand in some situations, notably for controlling reflections in

windows and also as a neutral density filter.

For infra-red shots, a deep red filter allows only red to pass through and prevents other colours of the spectrum from registering, and this can give the most satisfactory characteristic infra-red look to the final shot. Again, different looks may be achieved by experimenting with different colour filters.

Black and white printing and post-production techniques

The relative ease of DIY of black and white developing and printing has made it accessible to many an amateur darkroom enthusiast. In the commercial and professional context, the same factors of ease and accessibility apply, offering the photographer a high level of personal control over the final image, and a capacity for extensive personal experimentation without endless lab fees to pay. Techniques that are relatively easy to explore include tinting, toning, solarization, photogram images, silver gelatin prints, and hand-sensitising surfaces to print on. Examples of these techniques are featured in the chapters that follow, but the best advice that can be given is to go ahead and experiment: the possibilities and permutations are endless and fascinating.

PEOPLE and
PORTRAITS

01

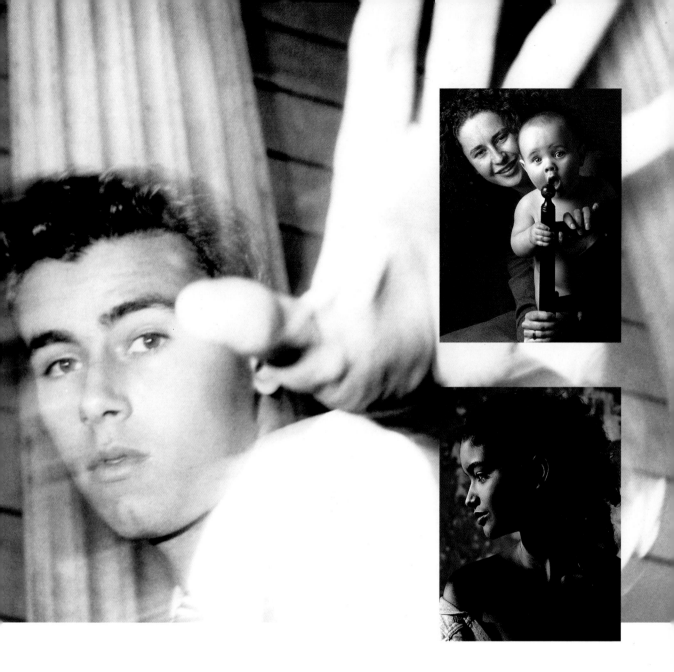

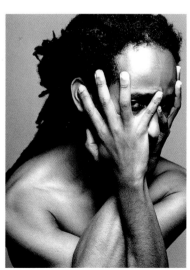

Black and white is a popular choice for portraiture because of its ability to convey a certain 'atmosphere' and truth of character and mood, over and above the 'truth' of colour, which seems less significant when personal portrayal is the issue. There is a timeless quality to many of the shots in this chapter. Whereas colour can have a tendency to date, the black and white portrait concentrates the viewer's eye on expression, texture and an indefinable inner quality of character, recording people at a point in time, as themselves, rather than as anonymous models.

Depending on the context, the lighting may need to be soft and compassionate, as in Dima Smelyantsev's "Mom", flatteringly even, as in Gerry Coe's "Kerry" or bold and adventurous as in Guido Paterno Castello's "Dhana". Ultimately, the photographer decides what the end result will be and positions lights appropriately.

MOM

photographer **Dima Smelyantsev**

use	Personal work
models	Lina Levitin and Eliah Levitin
assistant	Olga Terlitsky
camera	6x6cm
lens	150mm
film	Kodak Tri-X
exposure	f/5.6
lighting	Tungsten

The image of a mother cradling and suckling a child with the baby bathed in a pool of light is timelessly symbolic.

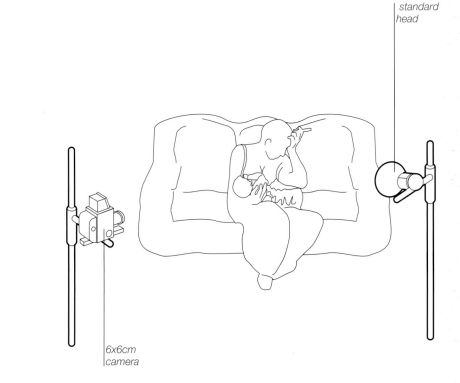

standard head

6x6cm camera

plan view

key points

A standard head is a dual purpose item: the modelling light can be used as a source in its own right

Parts of the actual subject can be used to flag light or position shadows

This shot contains all the essential components of the classical Madonna and child iconic image, but this is an unequivocally modern interpretation of the centuries-old theme:

The props, setting and styling set the mood and context. Although the subject matter can be read as a harsh view of motherhood, the style of the lighting is softer and gives a gentle, compassionate feel to a challenging subject. Rather than using a hard flash, the

photographer has used only the modelling light of a standard head, positioned well round to the right. The shoulder area, illuminated directly by this, provides a background against which the profile of the face stands out. Importantly, the arm flags the face from direct illumination. The baby is positioned to receive most of the light as appropriate, as it is very much at the centre of this particular universe.

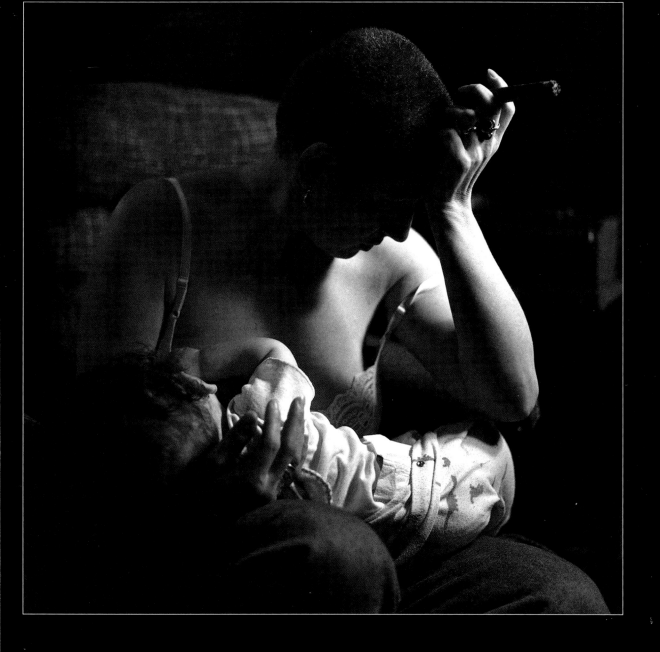

PORTRAIT OF AUBERON WAUGH

photographer **Tim Ridley**

use	Editorial
model	Auberon Waugh
camera	35mm
lens	35mm
film	Ilford HP5 rated at 1600 ISO
exposure	1/60 second at f/3.5
lighting	Available light, domestic light bulb

This is a situation where, although it seems that there is bright light available (evident from the highlights on the face), there is nevertheless very low light overall.

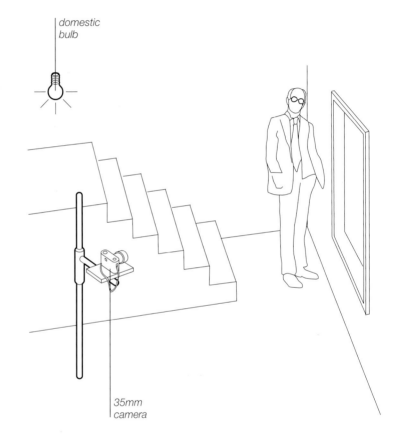

domestic
bulb

35mm
camera

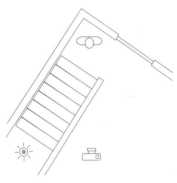

plan view

key points

Increased grain gives a gritty quality

Chromogenic films such as Ilford XP2 and Kodak Tmax 400 CN have a very wide exposure latitude and can be up-rated without having to push-process the film

The narrow, dark location and limited window access for the light to enter the scene means that the ambient light is, on most parts of the subject and setting, at a very low level. A bare domestic light bulb provides the only additional fill in this interior, and is responsible for reducing the otherwise very high lighting ratio. It also causes the shadow to fall on the wall behind the subject.

The necessarily large aperture, resulting in a shallow depth of field, puts the banister out of focus, ensuring that the viewer's interest remains on the subject and not primarily on the foreground handrail.

The contrast is high, and up-rating the film makes the contrast even higher.

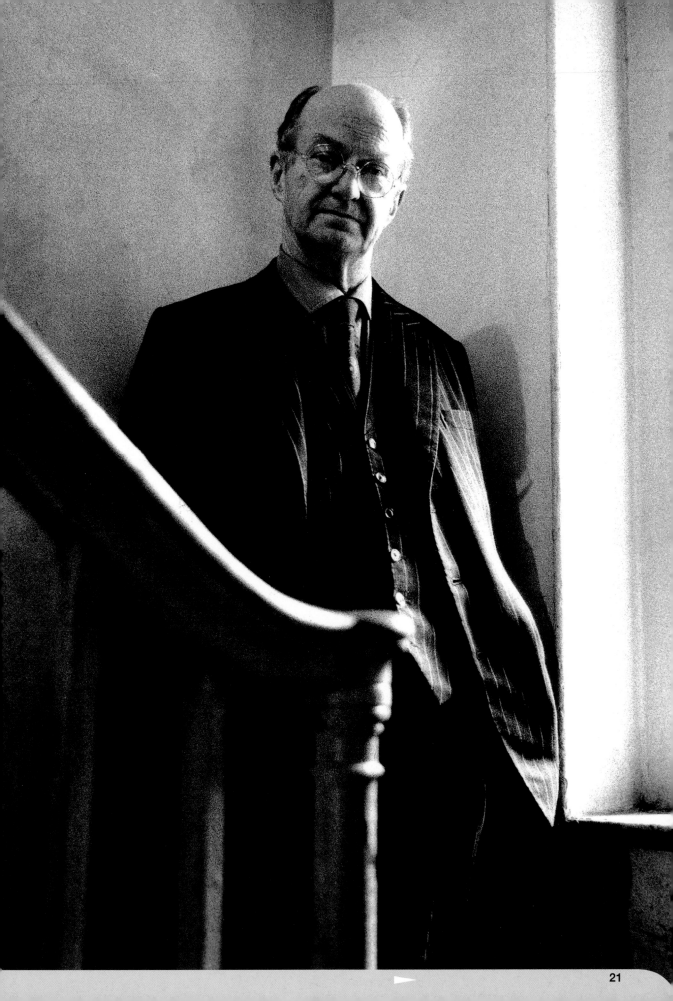

DUNCAN

photographer **Juan delGado**

use	Self-promotion
model	Duncan
assistant	Moncho Aldamiz
art director	Juan delGado
camera	645
lens	80mm
film	Agfapan 25
exposure	1/60 second at f/5.6
lighting	Electronic flash
props and background	Cyclorama (medium tone)

The model's steady gaze stops us in our tracks in this simple yet compelling portrait.

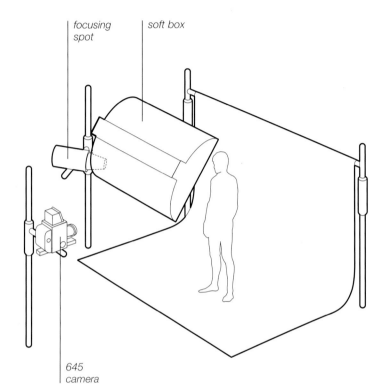

focusing spot

soft box

645 camera

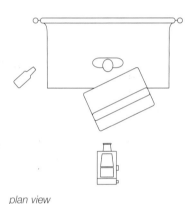

plan view

key points

A camera position just below the model's eyeline adds to the statuesque grandeur of the shot

It is a matter of careful judgement to achieve a good matt highlight rather than an over-bright unflattering shine, especially when working with dark skins. Contrast and exposure are the key elements

The main light is a 100x100cm soft box overhead, set at an angle so that it illuminates directly only the near side of the model's face; the model is standing so that the body is turned away from both the camera and the soft box, with the face tilted towards the lens to give a three-quarter, rather than directly face-on, composition. The expression and details of eyes, eyebrows, mouth and cheekbones are all skillfully and beautifully presented within this arrangement, to excellent effect.

A focusing spot light is aimed at the medium-tone background to highlight the fabric and provide some separation from the model's face, which is edged with a deep black outline on the side furthest from the soft box.

photographer's comment

I placed Duncan so that the light gleamed on his forehead. And by focusing on his steady gaze and avoiding any particularity of custom, I tried to emphasise an aura of simplicity.

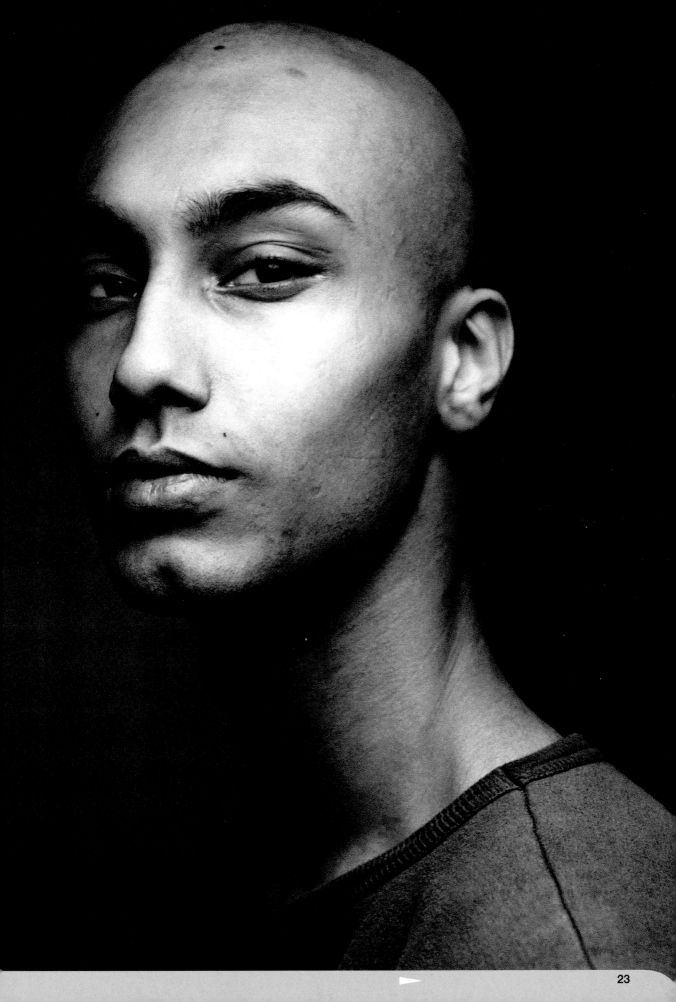

PAPARAZZI

photographer **Antonio Traza**

use	Portfolio
camera	6x7cm
lens	50mm
film	Ilford FP4
exposure	Not recorded
lighting	Available light and electronic flash

The typical paparazzi shot is the work of a split second; an opportunity either taken or missed. Simulating the spontaneity of such a moment can be a surprisingly difficult task. Movement, lighting, composition and expression must come together.

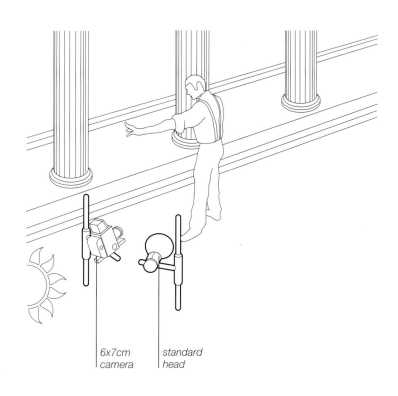

6x7cm camera standard head

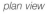

plan view

key points

The daylight is used to capture the movement while the flash is used to capture the 'moment'

The position of the hand against a dark area of the background is essential for the successful impact of the composition

"To get this frame, I needed to shoot a lot of film, for it was very complicated to get the right combination of elements: the hand, the movement and so on," says Antonio Traza.

The main light was soft daylight on a cloudy day. However, in order to achieve the typical look of an opportunistic paparazzi shot, he used a Norman portable flash. This provides the characteristic hard "overflash" look of a hard flash source used in a daylight location situation. The combination of flash and daylight captures the movement of the moment, since the flash illuminates only a part of the time of the exposure.

photographer's comment

The idea was of an image similar to those done by paparazzi.

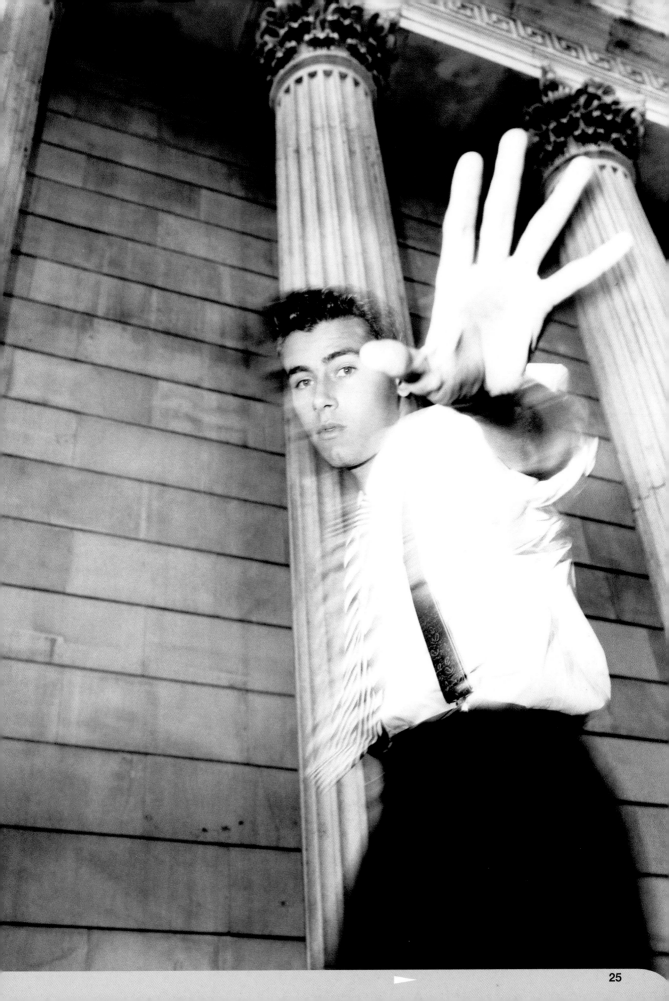

BROOKE

photographer **Holly Stewart**

use	Portfolio
client	Self promotion
model	Brooke Duthie
hair and make-up	Dawn Sutti
assistant	Rick Febre
camera	4x5 inch
lens	210mm
film	Plus-X
exposure	1/125 second at f/5.6
lighting	Available light and electronic flash

This interesting portrait unusually places a prop right at the front centre of the image, while the model subject of the portrait stays in the background and in soft focus.

plan view

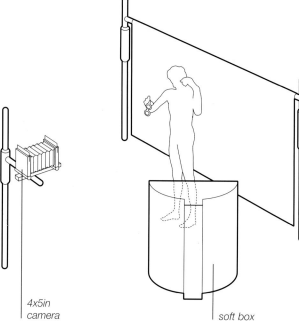

4x5in camera

soft box

key points

When using selective focus it is important to control it and use it to good effect, so that it does not look like a mistake!

When using reflective surfaces as props, be sure they are clean and smear-free

A strong sense of character nevertheless pervades the shot; this is the result of the combination of choice of model, pose, judicious use of prop, and careful lighting. A single 2x3-foot soft box at a close proximity is used to illuminate this subject. A large aperture is employed to keep the depth of field quite shallow, the spectacles being the main point of focus. They are held so as to avoid any reflection of the soft box and to keep the front of the hand in shadow to add to the interest of the composition. The positioning of the fingers and angle of the head are not accidental, but directed to give the light/dark areas of contrast that the photographer wanted.

photographer's comment

Feather the light so you get the mood for the portrait.

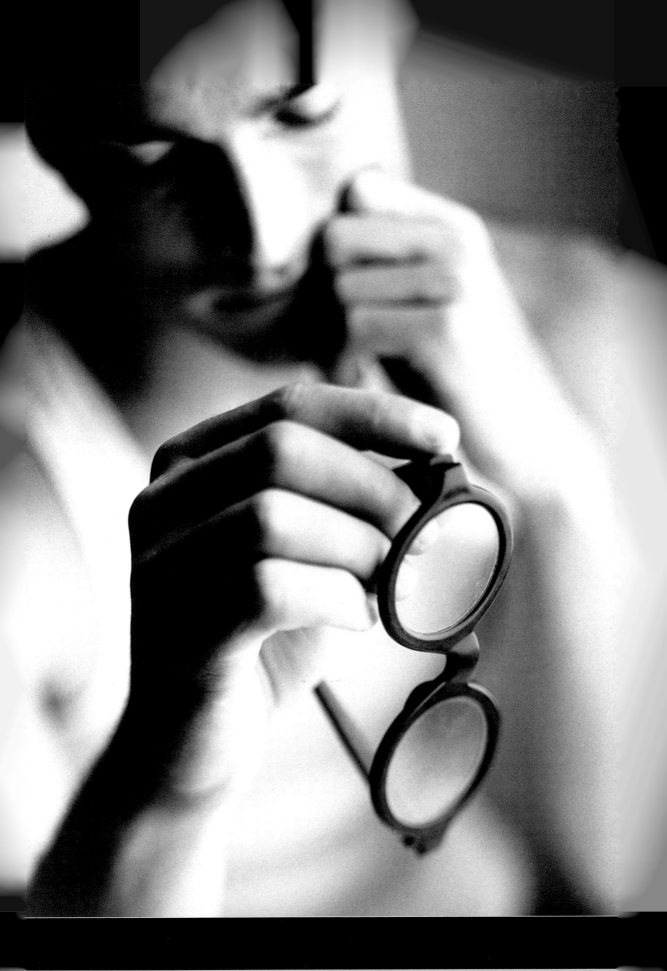

LARA AND JOHN DESROCHE

photographer **Ronnie Bennett**

use	Personal work
models	Lara and John Desroche
camera	645
lens	150mm
film	Kodak Tri-X
exposure	1/60 second at f/16
lighting	Electronic flash

The humour and vibrancy of the sitters is immediately striking here. Interestingly, both sitters are engaging with the photographer rather than with each other, yet the warmth of their relationship radiates through.

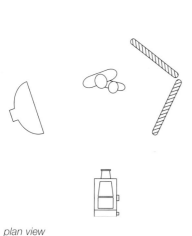

plan view

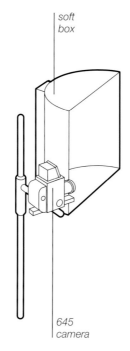

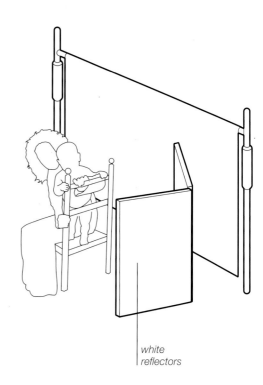

soft box

645 camera

white reflectors

key points

A low-key image is not necessarily a dark and gloomy image. The 'inner light' of personality has a large role to play

A good choice of props can motivate interesting posing

The faces shine out from the Rembrandtesque darkness created by the choice of a low-key background and the lack of light in the lower parts of the subject. If a light background had been used, the whole look would have been quite different, and the warmth of the expressions might have easily been lost.

In an effort to mimic the effect of window light, which she describes as "the most beautiful crystalline light there is", Ronnie Bennett used a soft box to camera left with two large white reflectors to the right to fill in the dark side of the subject.

The centre of the soft box was on a level with the baby's eyes, hence the clearly visible catchlights.

photographer's comment

Lara is an incredibly happy young mother with a joyful relationship with her baby, which is what I wanted to capture in my image.

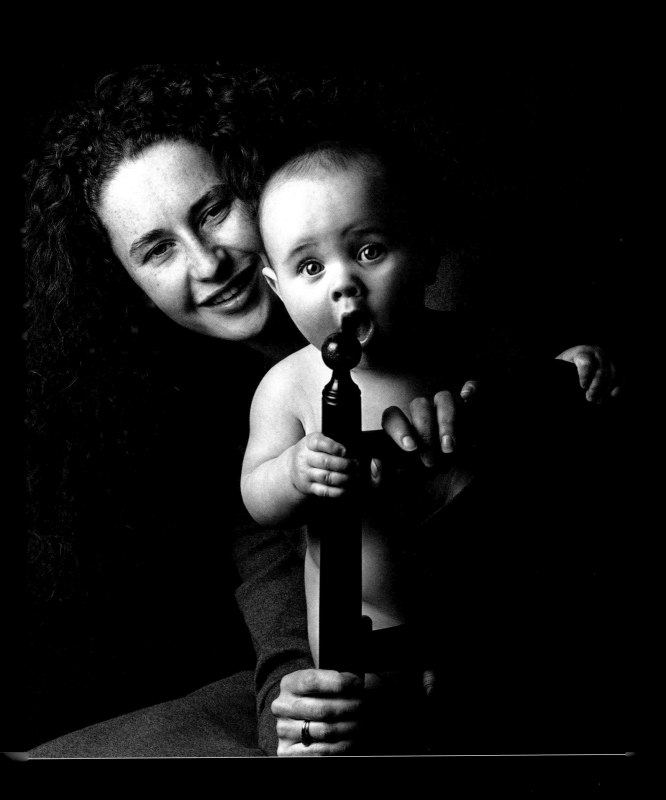

STACY FLOYD

photographer **David John Correia**

client	Stacy Floyd
use	Model Promotion
model	Stacy Floyd
camera	35mm
lens	105mm
film	Tmax 100
exposure	1/125 second at f/8
lighting	Electronic flash
props and	
background	Hand-painted blue background

With such a subject, the lighting needs to be used carefully to create separation between the model and the background to maintain accurate skin tones and details and to avoid unwanted hot spots.

plan view

35mm camera *soft box*

key points

Compare the catchlights in the eyes with those in Ronnie Bennett's "Jenny Harcom" shot. Different shapes and positions of the reflections offer a wide variety of possible effects

The hand-painted blue background offers the right tone. Dark blue is a better choice than black to reduce the contrast

In this case the photographer rose to the challenge by using a Photogenic Flashmaster head at 200 watts in a large Apollo Halo about two feet from the subject. The light was raised and feathered right for a one o'clock catchlight in the eyes and a tight Rembrandt shadow.

No background light was used, allowing the background to approach

black. The left side of the subject is defined against the background by means of silhouette rather than rimlight separation, while the right side of the subject, which receives the key light, is considerably brighter than the background and provides contrast of tone rather than a sense of recession or distance between the two planes.

photographer's comment

Photographing a black and bald model on a dark background can be challenging!

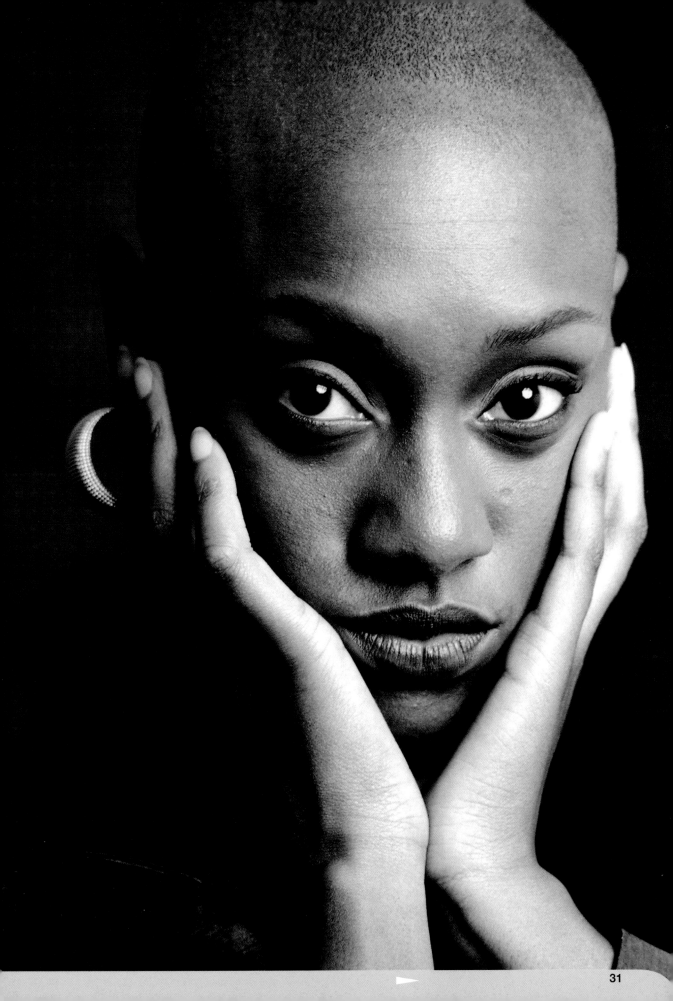

BABY IN BASKET

photographer **Gerry Coe**

Peekaboo! Timing is all when working with a very young model. Much time can be spent establishing a rapport and developing engaging play that will help to manoeuvre the baby into the right place, and with an appealing expression for the shot.

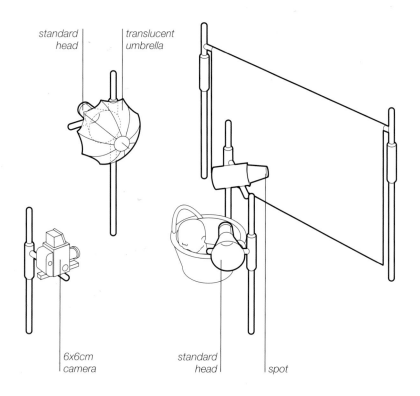

standard head · translucent umbrella · 6x6cm camera · standard head · spot

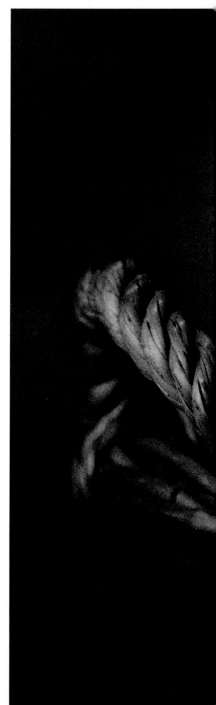

In this case the photographer may find it necessary to direct the parents (and perhaps use a favourite toy) in order to motivate the performance.

Four feet away from the baby on the left is a standard head, set about two and a half feet high, shooting through a translucent umbrella. A second head shoots away from the subject and allows light to bounce back generally from the studio walls, raising the ambient level slightly. Finally, a small light illuminates the background to give the halo effect behind the baby. Then all that remains to be done is serious play: the set-up is ready to capture the perfect moment – when it finally arrives!

client	Baby's parents
use	Commissioned portrait
camera	6x6cm
lens	150mm
film	Agfa APX 100
exposure	1/60 second at f/8
lighting	Electronic flash

key points

It may be helpful to encourage parents to rehearse a particular game with the child in preparation for the shoot, so that the same known pattern of play behaviour can be used in the studio to give at least some element of predictability

plan view

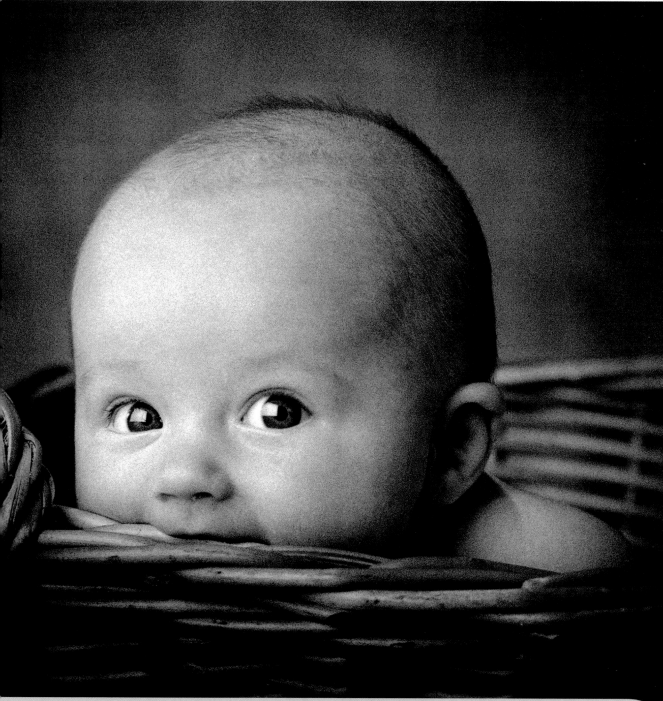

KERRY

photographer **Gerry Coe**

client	Child's parents
use	Commissioned portrait
camera	6x6cm
lens	150mm
film	Agfa APX 100
exposure	1/60 second at f/8
lighting	Electronic flash

With such blonde hair and fair skin, the light-toned background used here is well chosen as it ensures that the darkest and therefore most attention-grabbing element of the shot is the eyes.

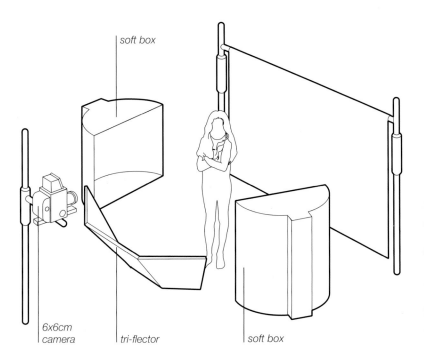

soft box

6x6cm camera

tri-flector

soft box

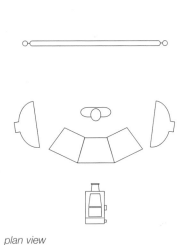

plan view

key points

Detailed differences of modelling will occur with the slightest variations of posing and position when working with this kind of all-round even light

A lighting ratio approaching 1:1 gives a very flattering smooth evenness to the complexion and 'look' of the model

As well as the light background, the lighting is set up to make the most of the dark pupils and dark natural rim to the irises, which are intensely striking and appealing.

The tight lighting ratio is achieved by the use of a soft box on either side, giving an almost symmetrical evenness. A tri-flector completes the semi-circle and reduces modelling even further. A light reading gave f/22 but Gerry Coe

chose to expose at f/8, approximately three stops over, to make sure all the detail of this extremely fair subject came through.

The positioning of the hands allows a little modelling to define the arms; the strand of hair to the right of the model's face and the exact angling of the head also allows a little modelling to occur along the nose.

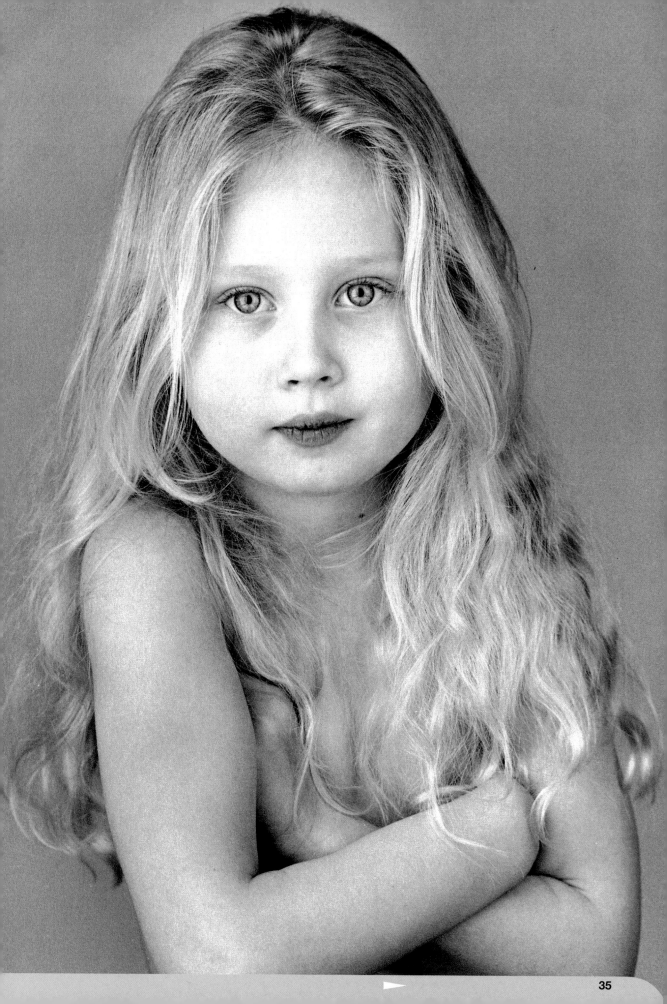

ERMIAS KIFLEYESUS

photographer **Ronnie Bennett**

use	Personal work
model	Ermias Kifleyesus
camera	645
lens	150mm
film	Kodak Tri-X
exposure	1/60 second at f/16
lighting	Electronic flash

"Ermias is a young Ethiopian painter and poet," says Ronnie Bennett. "He makes a living with his hands and uses them exquisitely. This is his own pose. I lit this picture with strong light from above to emphasise the mood that he personally created."

plan view

645 camera

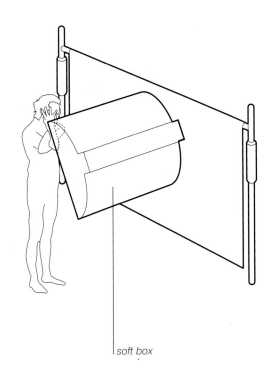

soft box

key points

Incident meter readings may need modification when the subject has particularly dark or light features

Use of overhead light is a good way to emphasise the dramatic qualities of an intense and brooding brow and eye facial configuration

The strong light is provided by a 2x3-foot soft box, positioned at close proximity overhead and slightly to the front of the model. This creates the strong contrast between the well-lit upper sides of the limbs, face and torso, and the very dark shadow areas on the down-turned surfaces.

In this extraordinary pose, the arms are contorted to quite different angles so the light skims down the foremost arm (the model's left), while the right arm is tilted upwards more, and the skin surface appears much brighter as it receives the overhead light full-on.

photographer's comment

Ermias is small and very slightly built, with wonderful graphic dreadlocks and an incredibly volatile face. I made a series of five pictures of him, in each of which he looks like an entirely different person.

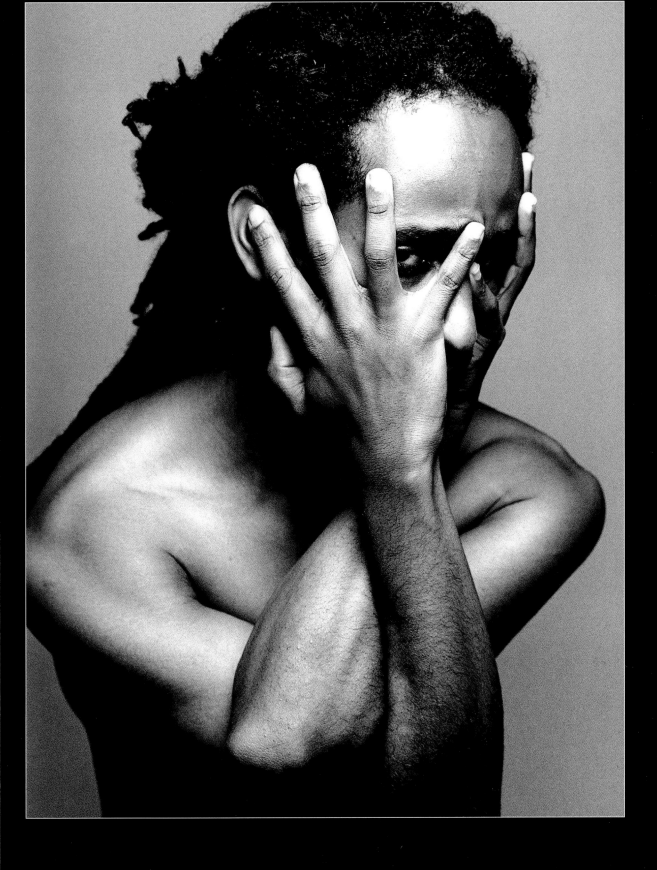

JENNY HARCOM

photographer **Ronnie Bennett**

client	Cathy Harcom
use	Personal work
model	Jenny Harcom
camera	645
lens	150mm
film	Kodak Tri-X
exposure	1/60 second at f/16
lighting	Electronic flash

Interestingly, the complete lighting set-up is visible in the catchlights in the model's eyes, which in this case are the finishing touch to a startlingly beautiful image.

plan view

soft box

645 camera

tri-flector

soft box

key points

The crown of the head does not require additional lighting. There is just enough of a suggestion of the form there already

Catchlights in eyes need careful consideration. Be aware of what reflections you are getting, and whether they will enhance or detract from the overall look

As the reflections show, the set-up consisted of a soft box on each side of the model, level with the eyes, and a tri-flector in front of her, just out of camera view. This set-up was chosen in order to throw as much flat light on to the face as possible. The hair, background and clothing are allowed to remain dark to act as a foil for the face.

The image was printed fairly hard on matt fibre-based paper to avoid any distracting specular reflection on the print; and the model's body was burned in from the neck down to achieve the glow in the face.

The small shadows on either side of the top lip were bleached out so as not to distract from the impact of the even glow of the face.

photographer's comment

Having shot a good number of conventional pictures of Jenny, I particularly wanted to emphasise her huge eyes and the delicacy of her heart-shaped face.

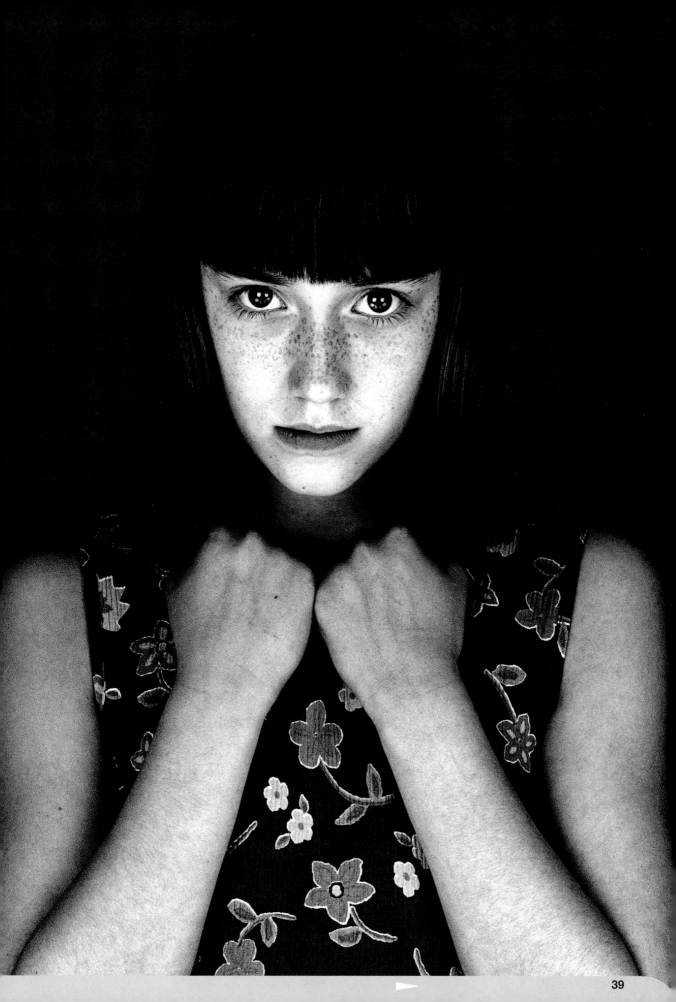

DHANA DE MONHA

photographer **Guido Paterno Castello**

use	Self-promotion
model	Dhana de Monha
camera	6x7cm
lens	127mm
film	Verichrome Pan
exposure	f/16
lighting	Electronic flash
props and	
background	Painted cloth

There are only two lights in this beautiful photograph.

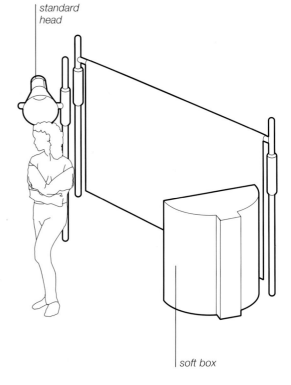

standard head

6x7cm camera

soft box

plan view

key points

Remember that you can either have a stationary subject and move the light, or a stationary light and move the subject in relation to it, with different effects

Temperature control is a factor to consider with regard to skin texture and therefore lighting interest

A one-metre-square soft box is placed at camera right to illuminate the background and provide an area of contrast to the model. The second light is a standard head positioned to the camera left and slightly behind the model. She turns her head sufficiently to allow some of the peripheral light – but not the very centre of the beam – to fall on the foreground of her face. This gives the exact amount of contrast

needed to create a strong image with powerful and yet finely controlled shadows and highlights. The air-conditioner was turned to full power in order to create the goose-bump texture wanted on the model's skin.

The standard head was slightly above and behind the model's head and the light was feathered. This was to place the hot spot away from the subject so as not to burn the highlights.

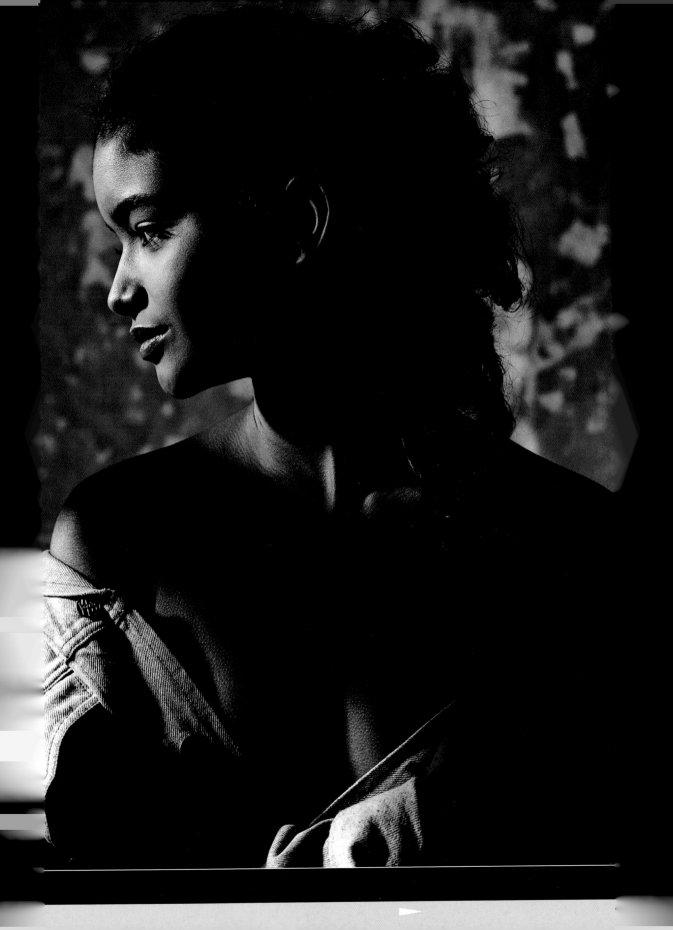

FINE ART

02

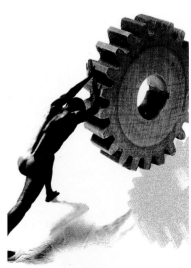

One of the beauties of black and white photography is the relative ease of completing the whole process oneself. There is no need for a lot of expensive equipment, painstaking control of temperatures, and so forth. This means that it is quite feasible to experiment and produce a more abstract or fine art end result within the medium. Of course, this has also been made far more accessible with the advent of computers, scanners and image manipulation software. However, to the purist it is far more rewarding to be in control, rather than at the mercy of the processor and programmer.

In this chapter several different techniques are represented (infra-red, montage, photogram) and at the heart of the creation process is the lighting. Light will always travel in straight lines but it is by controlling where light falls, and equally important, by controlling where it may not fall, that the fine art photographer manipulates and "sculpts" with light to produce a fine art image.

L'INTIMITÉ

photographer **Gérard de Saint-Maxent**

This beguiling image was produced using only available light and a reflector. The lighting set-up is straightforward enough, though expertly and knowledgeably exploited to excellent effect.

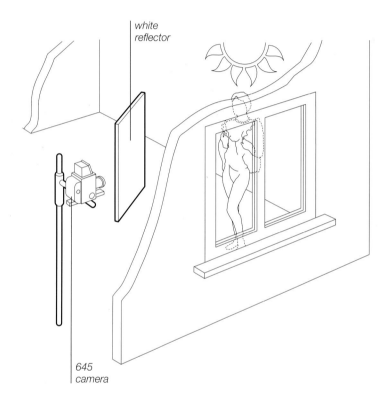

white
reflector

645
camera

Quite simply, the available light comes from camera right and a bounce to camera left provides some fill. The good amount of modelling to the curves along with the choice of dark lace against pale skin provides a wide range of tones to the subject. A small amount of camera movement was allowed in order to obtain a relatively fluid or fuzzy image.

The particular interest of the final image lies largely in the post-production finishing and presentation. Photographer Gérard de Saint-Maxent used a brush to apply light-sensitive emulsion to designer paper by hand: notice the deliberately ragged edges of the image.

photographer's comment

An extract from an exhibition work of fifty photographs.

use	Exhibition work
camera	645
lens	105–210mm
film	Tmax 400
exposure	1/8 second at f/11
lighting	Available light

key points

When sensitising paper using liquid emulsion, contrast can be varied by applying different amounts

The liquid emulsion can be applied smoothly or roughly, in broad or fine strokes, as required, to give a host of interesting effects such as raw edges or areas of different texture to the shot

plan view

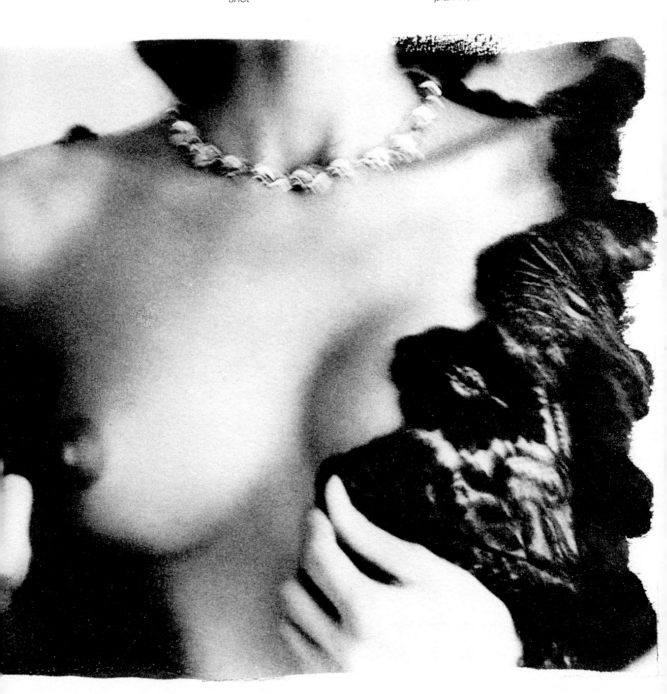

MOONLIGHT 1

photographer **Dima Smelyantsev**

client	Behr-Thyssen Limited
use	Edition of photogravures
model	Lana Mazo
assistant	Julius Glickstein
camera	6x6cm
lens	80mm
film	Kodak Plus X
exposure	f/16
lighting	Electronic flash
props and background	Matt black backdrop

At first glance, the content of this image may not be immediately apparent. Some may initially see a silhouetted head to the left of the frame, turned slightly away from the camera, tilted upwards towards a light. Others may identify the dark shape to the left of frame as a shoulder-to-waist figure silhouette, face on to the camera.

plan view

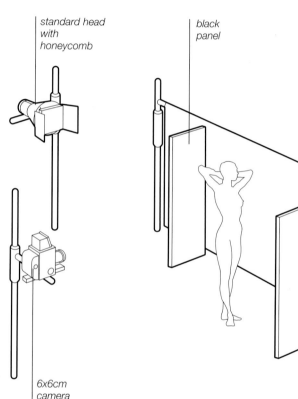

standard head with honeycomb

black panel

6x6cm camera

black panel

key points

Distance from the light source to the model is sufficient to increase the edge contrast

A totally non-reflective black background is essential for this kind of image

It is not necessarily immediately apparent that in fact the model is the area of light rather than the area of dark; the arm-to-hip profile is illuminated along the very edge. The eye and brain reinterpret and refocus each time the viewer looks at the image afresh.

In order to contrive this graphic sliver of illuminated torso, the positioning of the model in relation to

the light is crucial. Equally important is absolute control of any spill light on the background. Photographer Dima Smelyantsev has used black panels, one opposite the light source to eliminate any possibility of fill, and one to flag any light from spilling on to the background. The single standard head with 20° honeycomb then picks out the profile of the body.

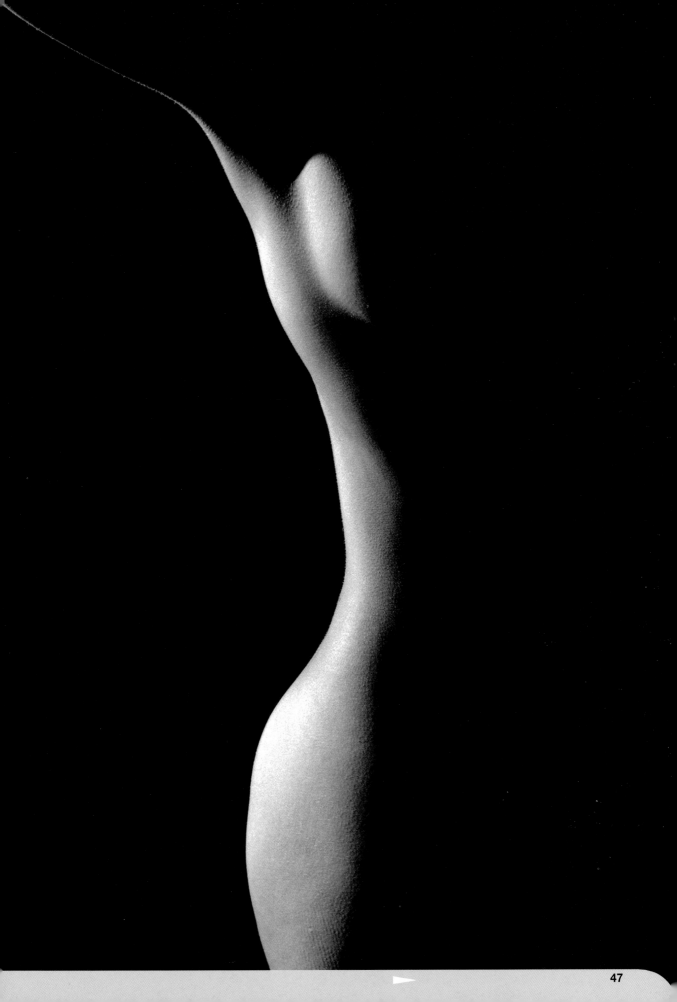

WORKING MAN'S SISYPHUS

photographer **David John Correia**

use	Personal work
model	John
camera	35mm
lens	35mm
film	Tmax 400
exposure	1/125 second at f/11
lighting	Electronic flash
props and	
background	White seamless background and a 3-inch cog

This image, which is a modern take on the Greek character, Sisyphus, consists of two shots, married together using Adobe Photoshop.

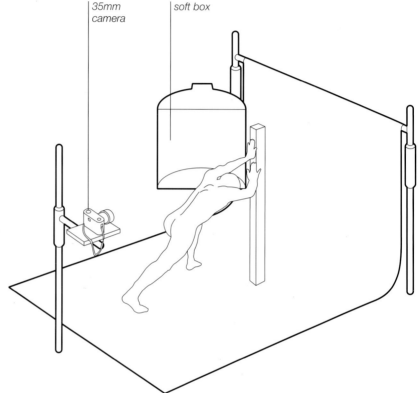

35mm camera

soft box

plan view

key points

Digitally-created varied textures within shadow areas can add interest

The absolute blank, crisp whiteness of the background, which sets off the whole image, is easily achieved digitally

The model was shot in the studio, using a large soft box positioned above and behind, as the highlights on the body indicate.

The 3-inch cog was then photographed in a table-top set-up with comparable lighting. A certain amount of artistic licence has been used with regard to the shadows, which appear to fall inconsistently in relation to the light sources. The skewed look that results works well with the high camera angle and creates a general feel of unearthly nightmare – an ideal mood for an interpretation of the eternal punishment of our hero, condemned to push the wheel (or a rock, according to ancient Greek tradition) uphill for eternity.

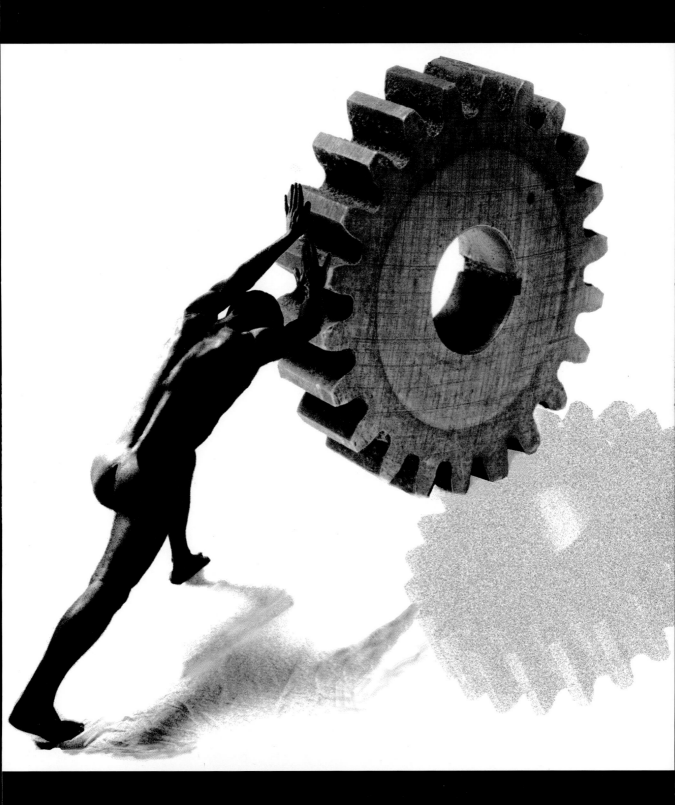

REGINA

photographer **Holly Stewart**

client	Self-promotion
use	Portfolio
model	Regina Shields
hair and	
make-up	Dawn Sutti
assistant	Rick Febre
camera	4x5 inch
lens	210mm
film	Kodak Plus X
exposure	1/125 second at f/5.6
lighting	Electronic flash

Partial or selective focus can be a powerful technique for emphasising specific features within the overall subject.

4x5in camera

soft box

plan view

key points

There is always something to be learned from emulating the work of Old Masters and contemporary high-class artists alike

The de-focused look does not necessarily require a 4x5 inch camera. A 35mm camera with a very long lens and a large aperture will give similar results. Neutral density filters may also be required

Here the model's eyes are the centre of the viewer's attention because the focus draws the viewer's eyes to them.

The other parts of the body – shoulders and throat – are, by contrast, de-focused. The hair is soft focus, and the result is reminiscent of the evocative pre-Raphaelite images from the early days of photography: this could almost be a Julia Margaret Cameron portrait from the 1860s or '70s.

The soft feathered light – i.e. the light emanating from the periphery of the light source, rather than the full central force of the light – provides good modelling and some play of light and shade across the face, rather than simple even illumination.

photographer's comment

The feathered light gives the mood needed for the portrait.

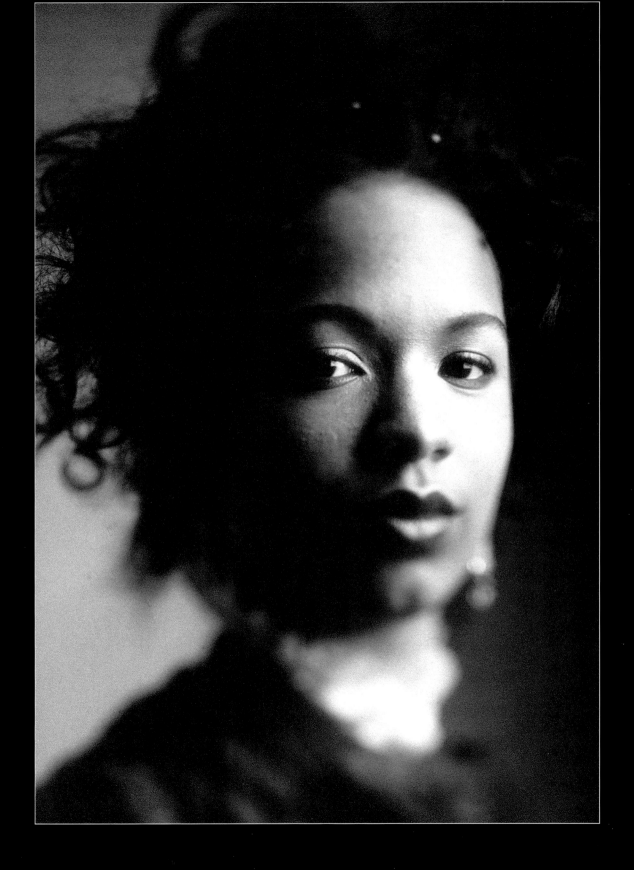

LUCINDA WITH SUNFLOWER

photographer **Ray Spence**

use	Exhibition
model	Lucinda
camera	6x7cm
lens	90mm
film	Ilford FP4
exposure	1/30 second at f/8
lighting	Available light and electronic flash
props and background	Rendered wall

With such an array of rounded and circular subjects, lighting for good modelling of curved surfaces and the emphasis of the geometric forms are important elements of the shot.

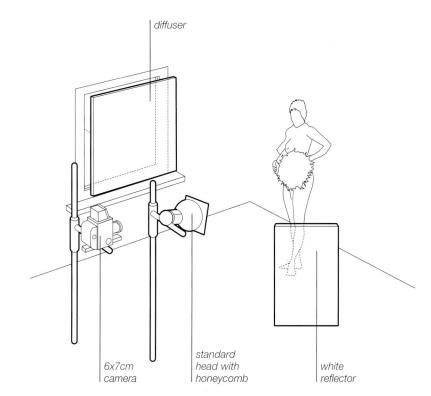

diffuser

6x7cm camera

standard head with honeycomb

white reflector

plan view

key points

Using the honeycomb increases the directionality and therefore gives stronger definition to the many seeds of the sunflower head

Diffusing the daylight from the window reduces directionality and contrast over the main area of the image

Ray Spence mixed daylight with flash for this. The daylight comes from camera left via a window draped with diffusing material, and is bounced back by a reflector to the right. This is sufficient to illuminate the smooth sweep of the model's body.

The intricate detail of the sunflower head requires specific additional lighting. The use of a standard head with a honeycomb gives good detail to the graphic patterns of the seed formations and petals.

The composition is particularly well judged here. Notice the dominance of the circle in the composition, an appropriate metaphor for an image that represents the ever-revolving cycle of life.

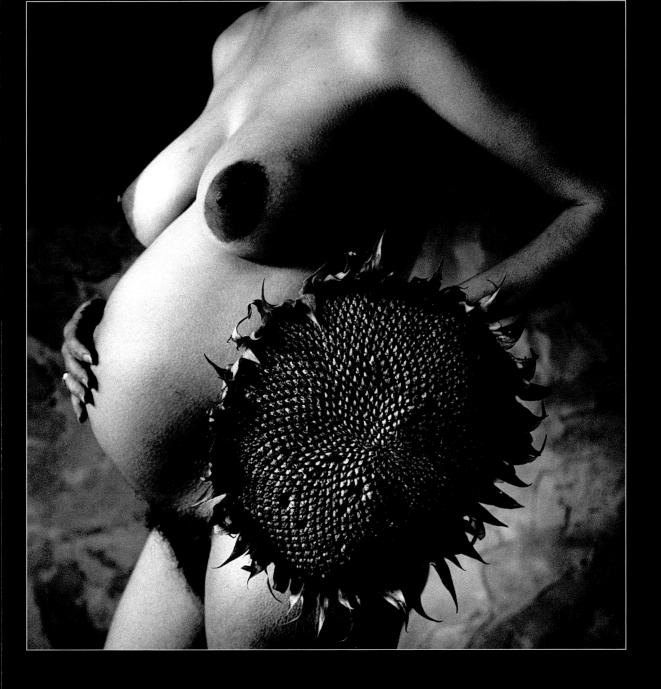

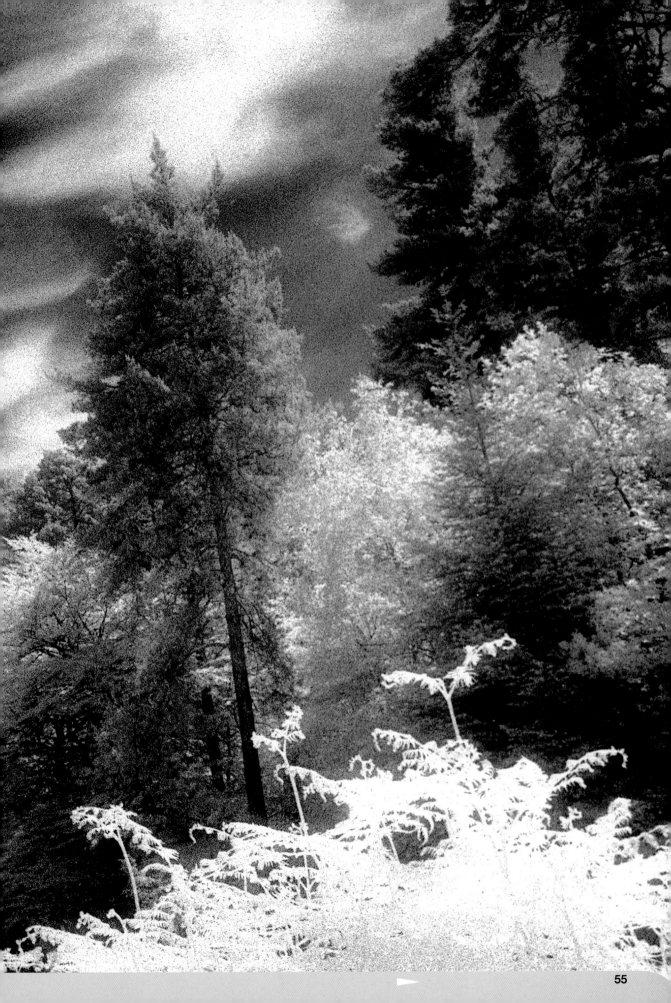

SKY DANCERS

photographer **Kathleen Harcom**

use	Personal
camera	35mm
lens	21mm
film	Kodak Infra-red
exposure	1/125 second at f/16
lighting	Available light
props and	
background	New Forest, Hampshire, England

This picture was taken just after midday on a summer's day. The sun was high in the sky and slightly to the right.

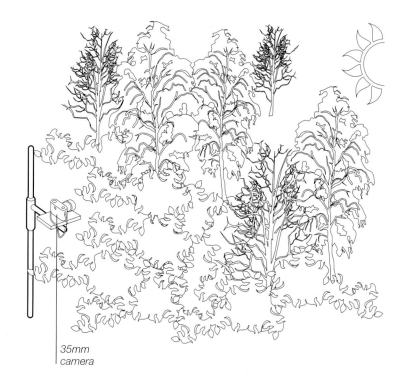

plan view

35mm
camera

key points

Use a deep red filter to filter out the rest of the spectrum because infra-red film is also sensitive to other wavelengths

Chlorophyll in foliage is particularly good at reflecting infra-red rays, and appears to glow in infra-red images

The light on the landscape was constantly changing because clouds were forming and unforming and moving swiftly in the wind. Cloud was completely covering the sun at times, so the photographer had to watch and wait for the exact lighting conditions and cloud formations to occur for the shot she wanted.

At the moment the picture was taken, the bracken was very well lit by the sunshine and this stands out. The trees in the middle ground were also variously lit with dappled sunshine, and the clouds complete the composition perfectly.

The photographer adopted a very low angle of view, getting down to the level of the bracken. This viewpoint, combined with the use of a wide-angle lens, has the effect of making the verticals converge, creating an exciting and dramatic composition.

photographer's comment

The cloud formations captivated me, as well as the sunlit green foliage of the brackens against the sombre Scots Pines. I used infra-red for extra impact.

RAIZES

photographer **Saulo Kainuma**

A stunning location and a very wide angle lens are the basis for this fascinating shot.

use	Personal
camera	35mm
lens	20mm
film	Tmax 100
exposure	1/60 second at f/2
lighting	Available light

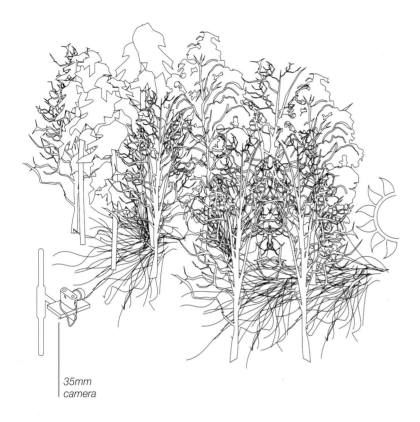

35mm
camera

plan view

The sun is to the right of the photographer and causes the foreground branches to be strongly side-lit.

The tree roots are in strips going back through the image which allows for interesting light and shade. Although the sky – which acts as a backdrop in this scene – is of course much lighter than the trees that stand against it, there is still enough light at this forest floor level to avoid a stark silhouette look, and to allow good detail and variation in tones and textures in the trees.

The dappled light, especially noticeable in the foreground area, indicates the low angle of the sun. Timing is all-important in this situation: the natural lighting is constantly changing.

key points

The sun moves surprisingly quickly, and it is important to have completed the preparation and research about the location, and to be ready and waiting when the perfect moment arrives

In case of mishap, it is a good idea to carry a mobile phone and to work with a colleague when on location, especially where the terrain may be awkward

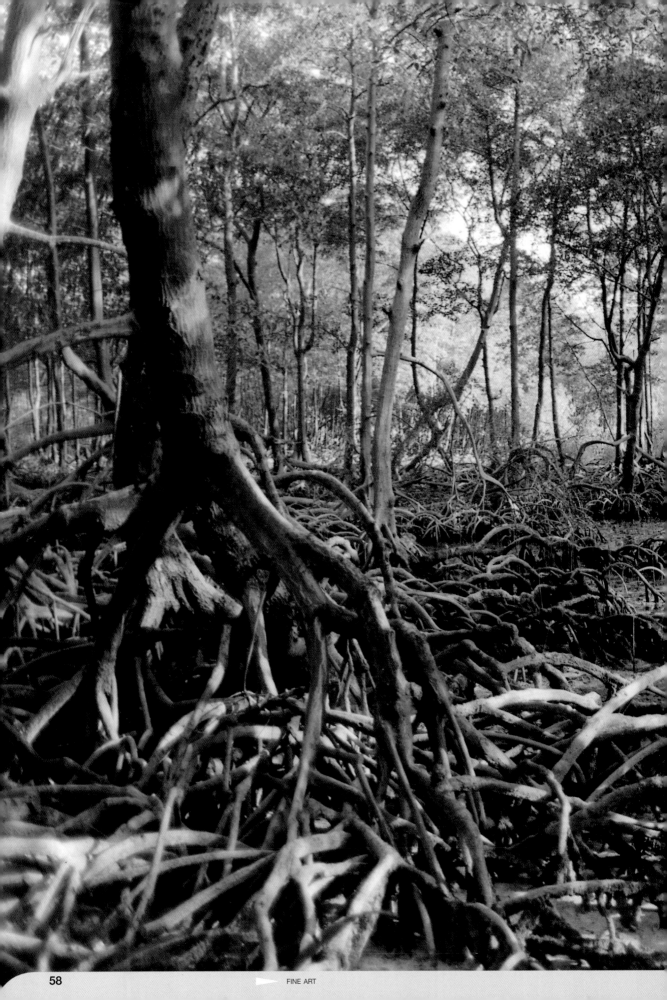

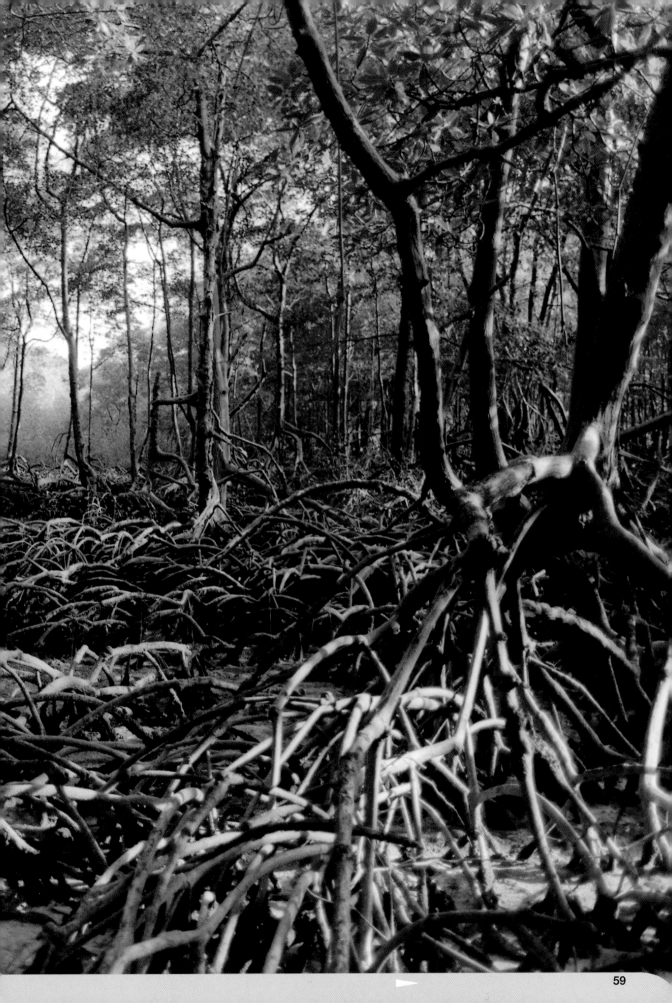

THE KISS

photographer **Tim Ridley**

use	Personal work
camera	35mm
lens	70mm
film	Ilford HP5 rated at 800 ISO
exposure	1/30 second at f/5.6
lighting	Available light

This dramatic film-noir style works well with the close-in composition and overall soft look.

plan view

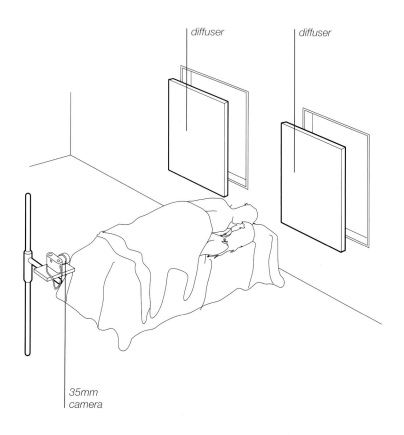

diffuser *diffuser*

35mm camera

key points

It is important when shooting towards a light source to avoid flare, which in a situation like this might appear as a milky cast

Net curtains can act as diffusers, although if they are patterned and the sun is not overcast the curtains will act more like a gobo

The shadowy quality of the eyes and lips (the centres of interest in such a shot) adds to the impact and romantic allure of the composition. The light here is from two windows on the far side of the models, with tracing (diffuser) paper over them; these act like two soft boxes. The positioning of the models in relation to the incoming window light is all-important: in this position their own physiology creates areas of shade at just the right points; their eyes and mouths are out of the direct line of light, while the uppermost surfaces of their faces receive a smooth even sheen where the light does fall directly on the skin.

The slow exposure allows some movement to be caught to add to the softness of the shot, and printing on textured paper further softens the atmosphere.

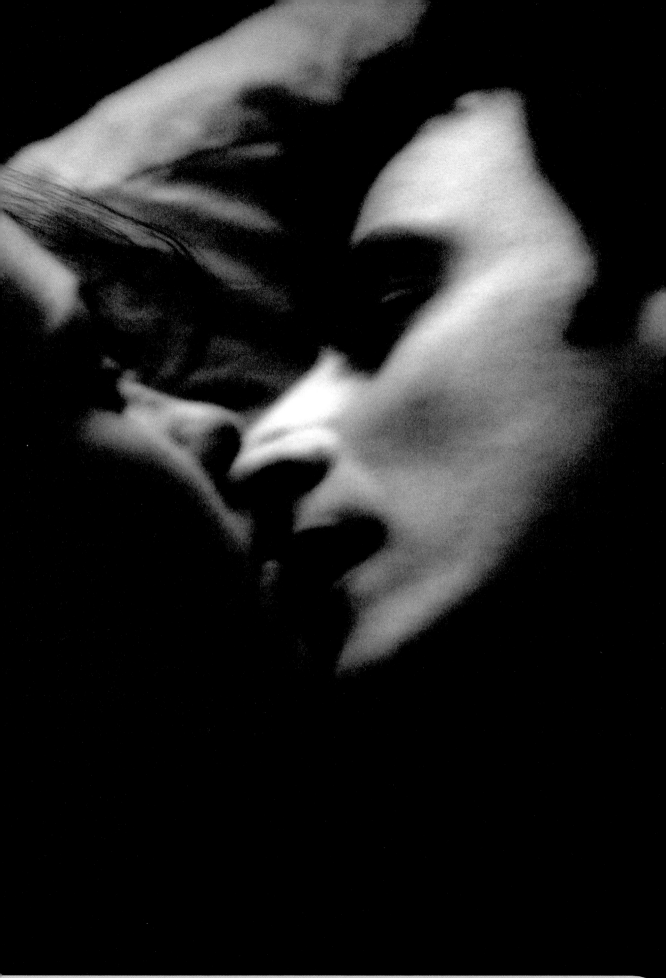

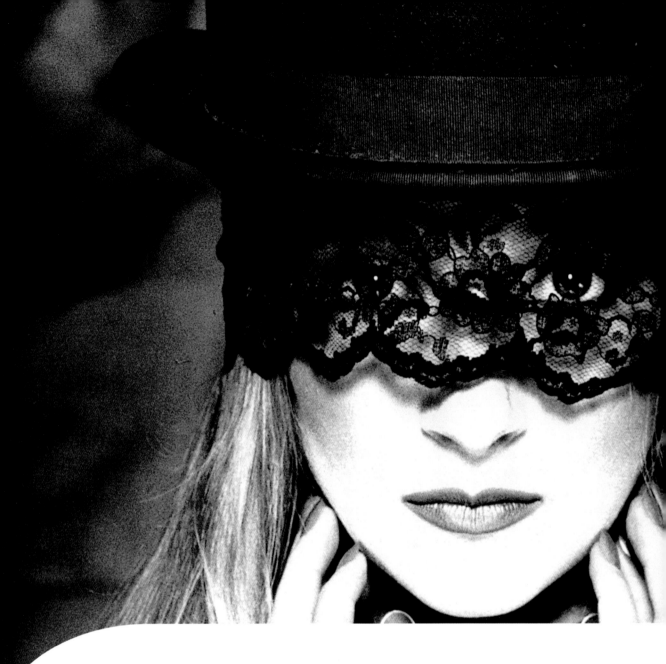

FASHION
03

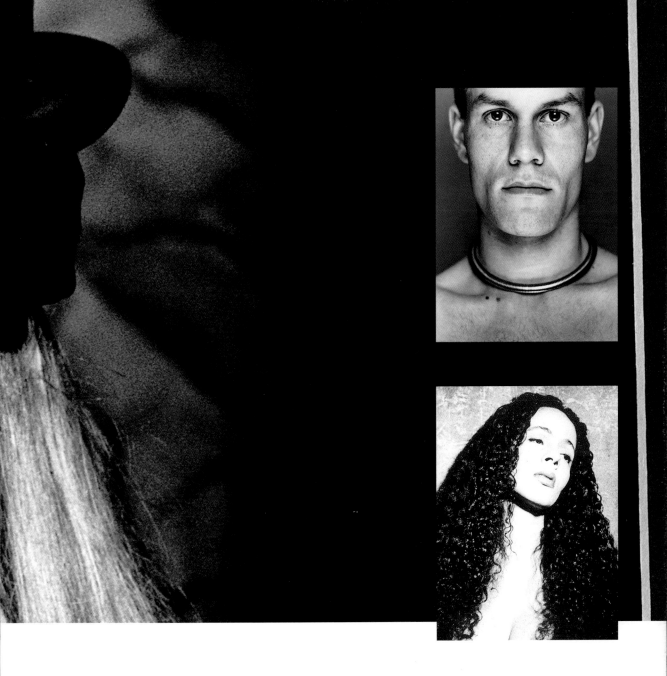

It is interesting to notice the extent to which black and white imagery is used to promote fashion items of all kinds, from perfume to clothing and accessories. This is, perhaps, because in black and white editorial fashion shots, a strong branding image, mood and lifestyle can be powerfully conveyed, sometimes more effectively than by a colour shot. The obvious limitation is that the actual colour of an item cannot be directly represented, but this can be made up for by the strengths of the overall image. When photographing a garment, for example, such aspects as the cut and line, stitching and folds can be beautifully portrayed. Similarly, the sculptural elements of accessories can be emphasised to put across the strengths of design per se – an extremely important element in the fashion world.

Lighting styles themselves go in and out of fashion. Recent trends evident in the fashion pages and magazines are for harsh lighting as well as quite dark overall images, and these trends are reflected by the selection of shots in this chapter.

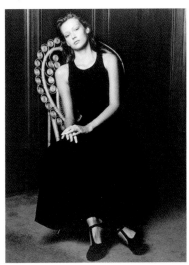

TRANSFORMERS

photographer **Juan delGado**

use	Self-promotion
model	Champan
art director	Juan delGado
camera	35mm
lens	80mm
film	Ilford HP5
exposure	1/60 second at f/5.6
lighting	Tungsten
props and background	Sequin curtain

The image was taken on location while the performer was acting. The unexpected appearance and nature of the performer is arresting enough in itself; but it is also the wealth of textures, forms and voluptuous three-dimensional forms that makes this a fascinating subject.

plan view

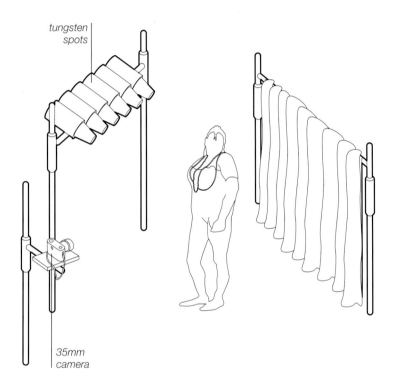

tungsten spots

35mm camera

key points

On location in a theatre, as at a catwalk show, it is essential to watch constantly in order to anticipate a well-lit, well-composed moment

Coloured gels on theatrical lighting will significantly reduce lighting intensity

Having seen the performance several times before, the photographer was familiar with the choreography and ready and waiting in position. What Juan delGado describes as a grove of spotlights overhead is in fact the theatre lighting. This mass of overhead sources gives top-most lighting, resulting in an even sheen of light and strong sense of modelling across the satin-clad curves of the torso, yet equally allows for the sharp highlights on the pearls of the necklaces to appear quite distinctly. The lower areas of the subject remain in relative darkness: the lighting rig is high up and almost overhead, so that the upper parts of the body shade the lower parts.

photographer's comment

Illusion defines the appearance of drag. Famous drag-artist Ru Paul said that "you are born naked and everything you put on after that is drag". In this portrait I wanted to underline this idea by mixing up the real hairy chest and the artificial wig.

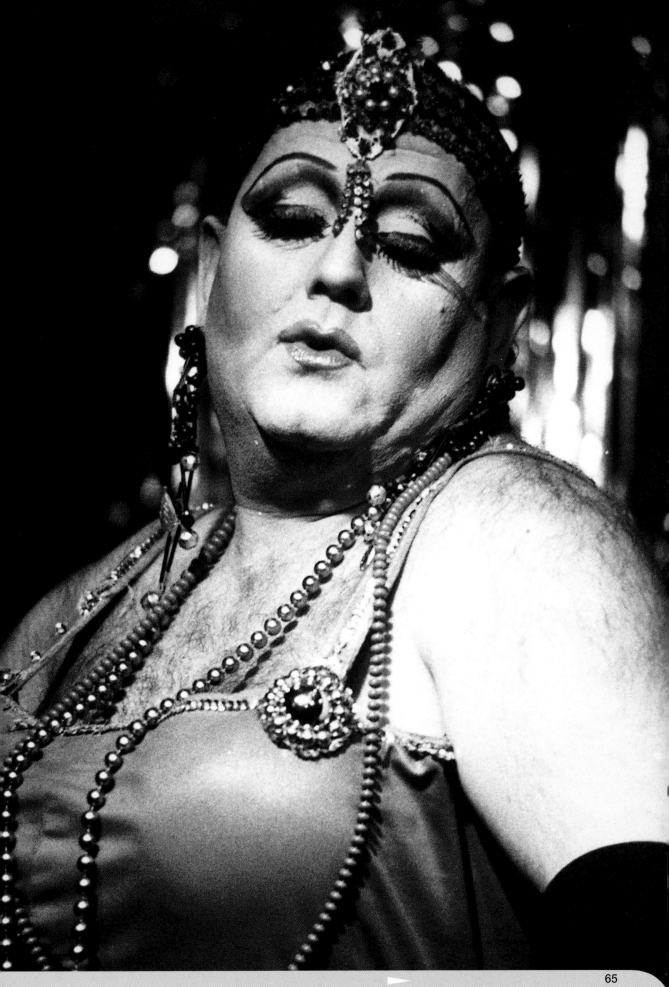

UNTITLED

photographer **Antonio Traza**

use	Portfolio
camera	6x7cm
lens	127mm
film	Ilford FP4
exposure	1/60 second at f/8
lighting	Tungsten
props and	
background	Hand-painted background

Fill light is often a concern, and many types of reflectors and bounces are constantly being promoted; to read the publicity it would seem that no photographer can ever work without them. However, actively choosing against fill light is another important option that should not be overlooked; it can be a very effective technique in the repertoire of the photographer.

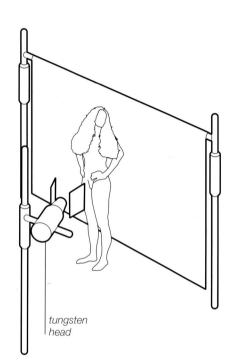

6x7cm camera

tungsten head

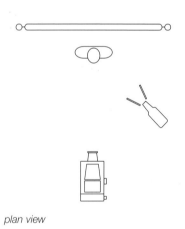

plan view

key points

Tungsten lighting has a reputation for being particularly suitable for model-based shoots

Be alert to opportunities as they arise: unique potential models may cross your path at any time

Antonio Traza explains the thinking behind this stunning yet simple shot: "I wanted to create a very graphic picture with strong shadows," he says. "I only used a 2 kw blonde tungsten light very close to the camera to minimise the shadows on the subject. To make the image more graphic, I didn't add any fill light."

The result in this instance is a bold, high-contrast image with graphic composition and yet good detail in, for example, the gleaming curls of hair, which were, after all, the inspiration for the image in the first place.

photographer's comment

This girl wasn't a model. I met her through a friend and I loved her hair. I wanted to do a picture that accentuated the forms and graphic details of the hair, so I printed on Ilford multigrade paper with lith developer which gives a very strong graphic look with some grained details.

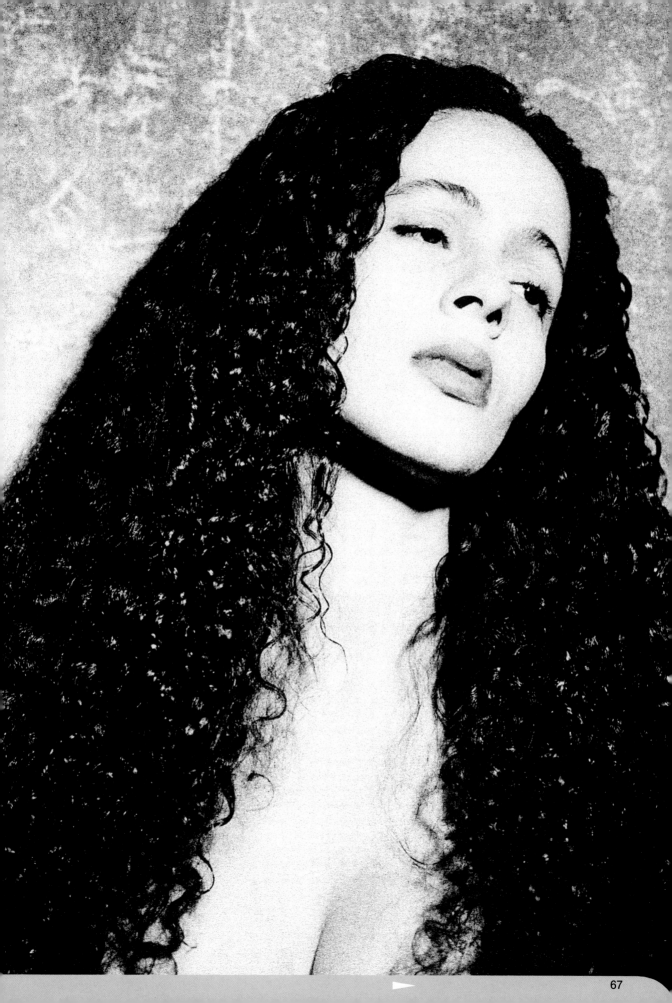

JORGE

photographer **Juan delGado**

use	Self-promotion
model	Jorge Tarrega
art director	Juan delGado
camera	645
lens	105mm
film	Agfapan 25
exposure	1/60 second at f/5.6
lighting	Electronic flash
props and background	Cyclorama (medium tone)

Although the basic composition is that of the familiar "head shot", there is a warm, glowing quality and an appeal that is anything but everyday.

plan view

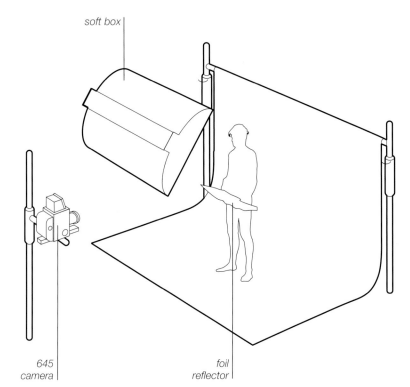

soft box

645 camera

foil reflector

key points

Many common items can be employed as reflectors, giving different kinds of effects. Foil, hand mirrors, silver-backed plasterboard, shiny wrapping papers and so on, are all useful

Jewellery must be spotlessly clean to avoid unsightly fingerprints

The warm, soft lighting is the result of reflecting light on to the subject via a generous amount of crumpled foil, a set-up that Juan delGado describes as a "reliably attractive lighting arrangement to give a high-key, low-contrast effect".

In this case the model himself holds the foil just out of the camera's sight. The large overhead soft box provides overall illumination (and the highlights on the necklace) but it is the foil that supplies the pleasingly gentle, warm, mottled effect on the skin.

It is interesting to notice the double catchlights in the eyes, one set from the soft box and the other from the foil reflector, and these are differently shaped accordingly.

photographer's comment

The photographer indicates the limits of the subject and his relation to it by selecting his distance and point of view. Thus he establishes his frame. I photographed just the face, identity is established by the features, the glance, and the bearing of the head, mapping the expressive topography of the face.

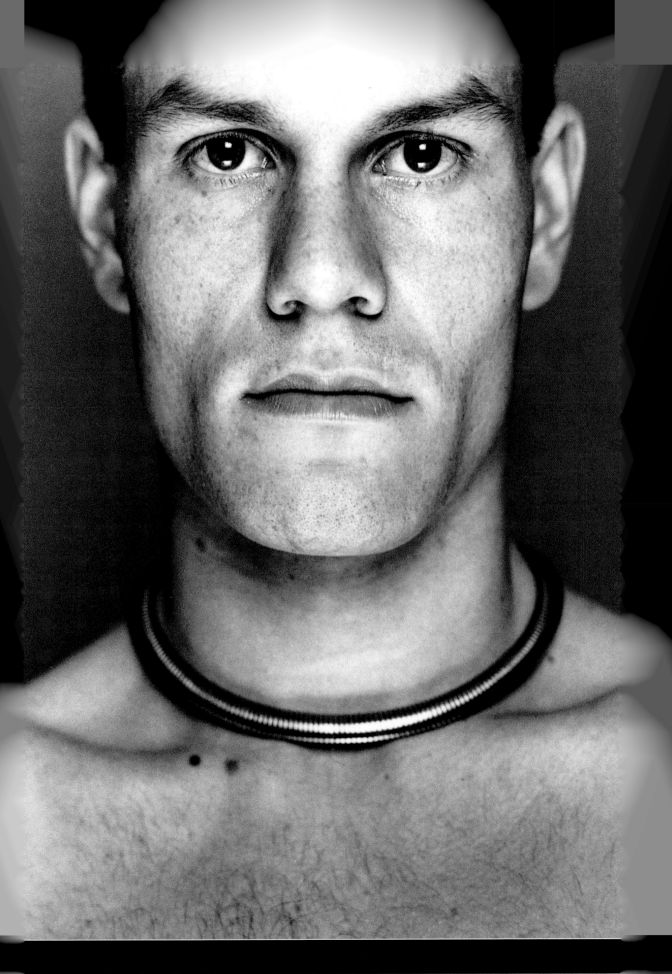

MAN ON RIVER

photographer **Holly Stewart**

use	Self-promotion
camera	35mm
lens	35mm
film	Ilford XP2
exposure	f/16
lighting	Available light with on-camera flash
props and background	Mississippi River

The surface of the Mississippi River acts here as a huge reflector of plentiful light from a big sky. The challenge is to attain sufficient separation between the water and sky areas, which tends to white, and the shirt of the model, which is also white.

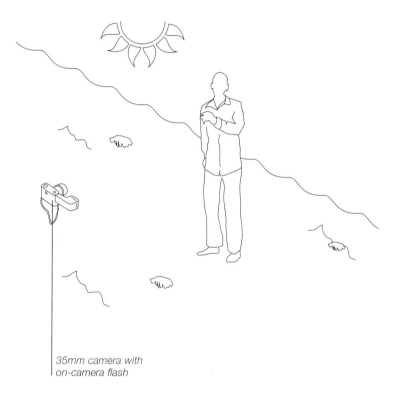

35mm camera with
on-camera flash

plan view

key points

Water and clouds can act as reflectors depending on the conditions of the moment. It is worth studying their behaviour in order to gain the most from the natural phenomena

Flare can be used creatively to add to the impact of an image

By positioning the subject at a point out of direct sunlight, Holly Stewart has ensured that initially the shirt is relatively shaded, as is the face. The model's head is then tilted up enough to catch some of the available light in the eyes and on the upper head, and the on-camera flash finally lifts the whole of the foreground subject just enough to reveal the required amount of detail to the clothing and facial expression. As an exemplary exercise in shades of white and how to differentiate them, this is a shot that repays careful study. As a well-composed and interesting visual shot, it is equally rewarding.

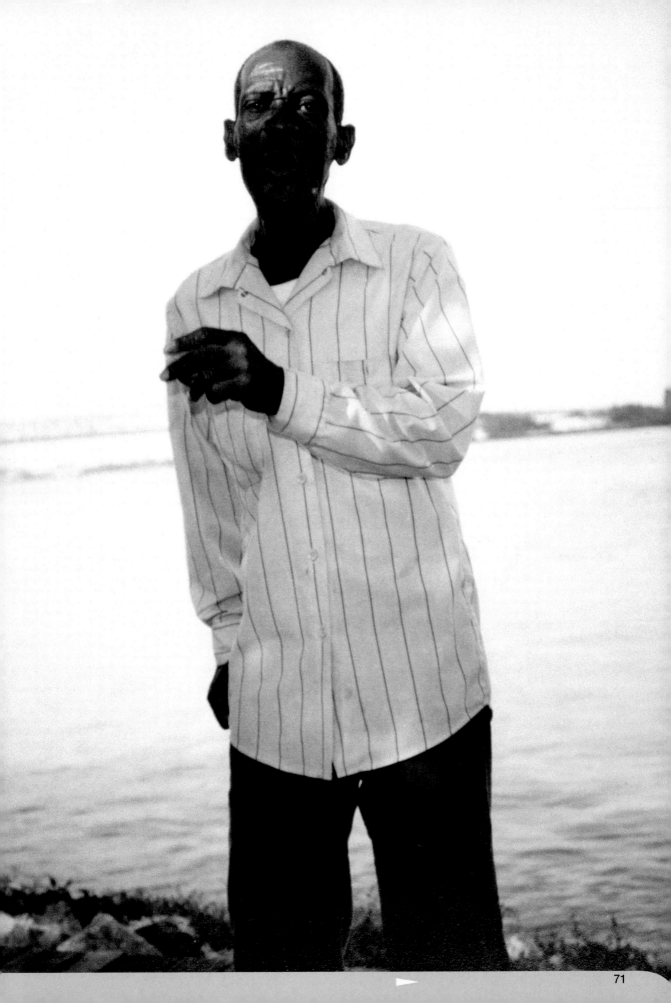

WOMAN AND CHAIR

photographer **Antonio Traza**

use	Personal work
camera	6x7cm
lens	127mm
film	Ilford FP4
exposure	1/250 second at f/8
lighting	Electronic flash

Simplicity is the watchword for this shot. "I wanted to get a picture which communicated simplicity and showed the beauty of the model," comments Antonio Traza.

soft box

6x7cm
camera

white
reflector

plan view

key points

Interesting props can be rented from specialist prop houses

Less is more: don't make things any more complicated than is necessary

The lighting is, indeed, very simple: Antonio Traza has used just a very big soft box to camera left, imitating daylight coming through a window, and a reflector to camera right to provide a little fill. The pose, fashion clothing items and setting come together to give a strong yet beautifully simple composition. The ornate pattern of the chair back adds just enough decorative detail and provides some separation between the model and the background.

The final image was printed on Kentmere Art Classic paper.

photographer's comment

I find it is better to keep lighting to a minimum when doing fashion so it is possible to concentrate on the subject.

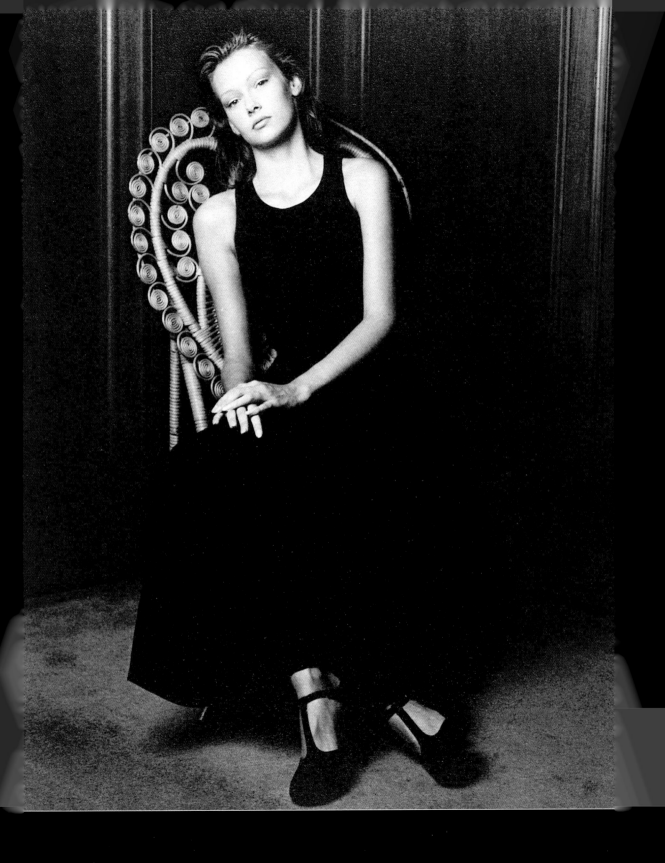

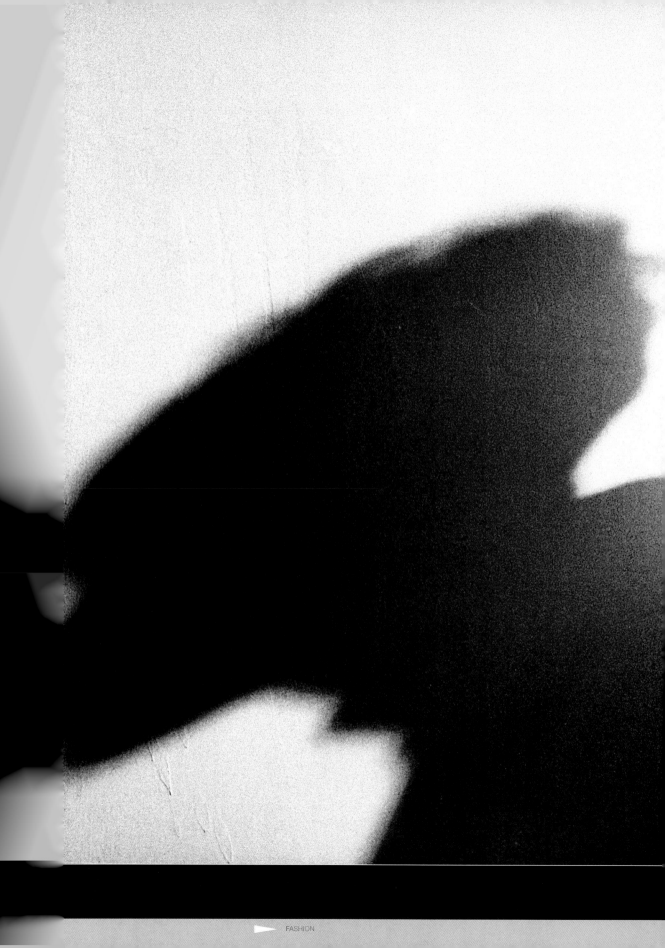

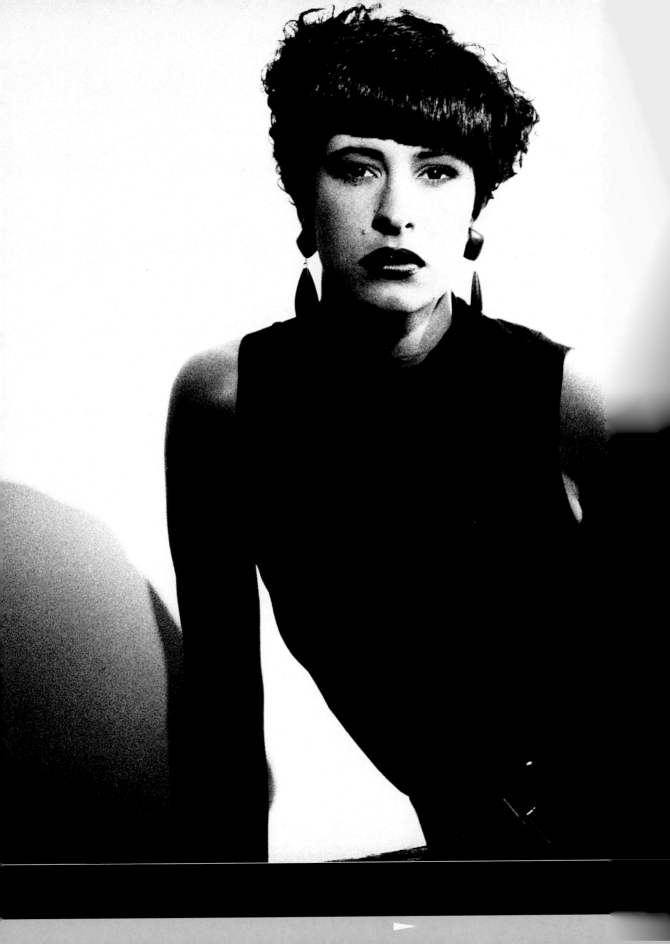

SHADOW

photographer **Ray Spence**

use	Model card
camera	35mm
lens	90mm
film	Kodak Infra-red
exposure	1/125 second at f/16
lighting	Available light

The fun that is to be had out of distorting shadows is familiar the world over. From party-game hand-shadows to oriental shadow theatricals, the impact and appeal of the shadow seems to be ever-enduring.

plan view

35mm camera

key points

Infra-red film flattens skin tones and produces a grainy image

Playing with shadows can give unexpected results and unanticipated resonances. Be willing to take the time to experiment

In this shot, Ray Spence has contrived a shadow that is difficult to relate to the subject. The elongation of the skull and the angle of head to torso makes it appear as a kind of caricature – looking something like the profile of Early Man, or other primate ancestors. By contrast, the model herself has classic well-proportioned beauty, and the humour lies in the discrepancy between the person and the grotesque shadow.

Careful positioning of the main elements of the shot – light source, model, background and camera – are obviously significant. The sidelong sun and proximity of model to background are the main considerations, and although there is little mystery to such a simple set-up, a great deal of skill and judgement is employed to bring off the final image with such aplomb.

SAXOPHONE

photographer **Holly Stewart**

This image is a composite consisting of two discrete
photographs by Holly Stewart, then worked on and
completed by the US designer, Jennifer Morla.

use	Self-promotion
model	Cyndra
assistant	Rick Febre
stylist and	
make-up	Dawn Sutti
camera	6x6cm
lens	210mm
film	Kodak Plus X
exposure	1/125 second at f/5.6
lighting	Electronic flash

6x6cm
camera

soft box

plan view

The two photographic elements of the
image, the saxophone and the model,
were shot separately, but with very
similar lighting set-ups.

 For the saxophone, a soft box on
camera right was used, feathered in
order to illuminate the whole of the
instrument and to place a hot spot on
the bell. For the model, again a single
soft box was used, but this time was
placed on the left of camera.

The solid circles of light and the
trails were added later by the designer,
after the two photographic components
had been assembled as a single image.

 The harmony of the whole reflects
the styling of the inspirational sources
that Holly Stewart names – the
dramatic film noir look; the dapper
very-black black and very-white white
fashion of the 1930s era, and the
surrealist Man Ray touch.

key points

*Composite shots need
complementary lighting for each
element, which is not necessarily
identical lighting in each case*

photographer's comment

A tribute to Man Ray, film noir and the glamour of the 1930s.

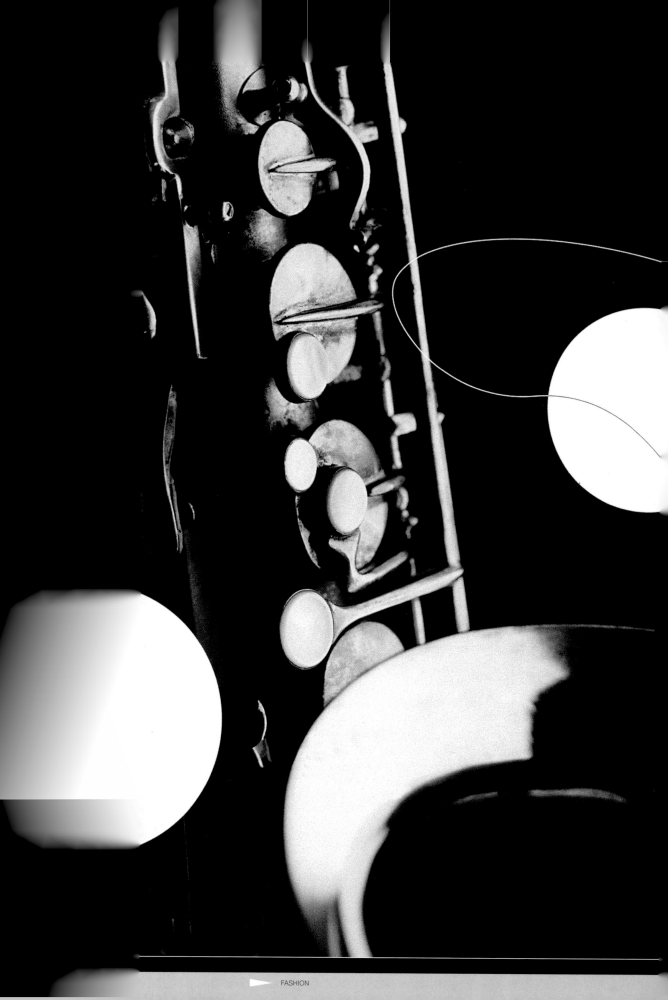

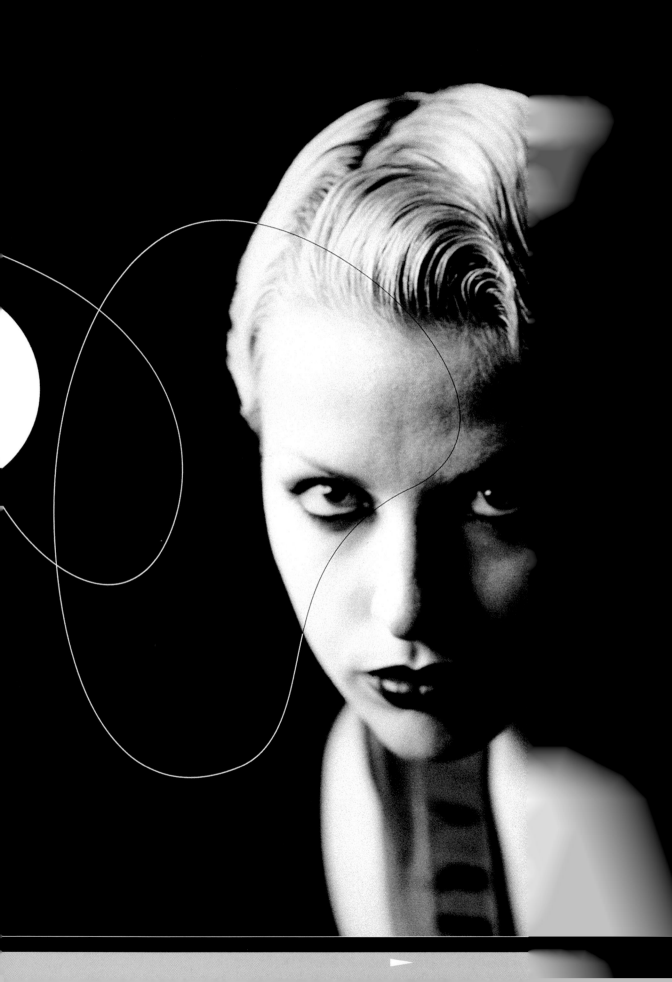

LOUISE

photographer **Björn Thomassen**

client	Louise
use	Model portfolio
camera	645
lens	150mm
film	Tmax 400
exposure	1/250 second at f/11
lighting	Electronic flash
background	Lastolite black paper

This is a low-key set-up in terms of props, with the black bowler hat, the black lace mask and the black paper backdrop and black velvet dress. Yet the hair, arms and face are high key.

soft box

645 camera

tri-flector

spot

plan view

key points

Extra brilliance on selected areas of an image can be achieved in the studio via the lighting, in the darkroom by holding back during printing, or by means of applying bleach to the printed image

The background texturing comes solely from distressing the paper background and lighting it from an acute angle to make the most of the newly-created contours

This combination results in a graphic flatness to the subject, which is a very typical style of fashion shot.

The main light is a 4x4-foot square soft box above the camera and square on to the model. A tri-flector is placed close to the model, just out of frame. This set-up results in the flatness and helps to suppress skin texture.

A spot is placed behind the model pointing upwards to light the

background. This background light is set two stops higher than the main light to produce a halo of light on the background for separation around the model's head with rapid fall-off.

The Lastolite black paper background is crushed and creased for effect. The print was bleached on the face area using Farmer's Reducer.

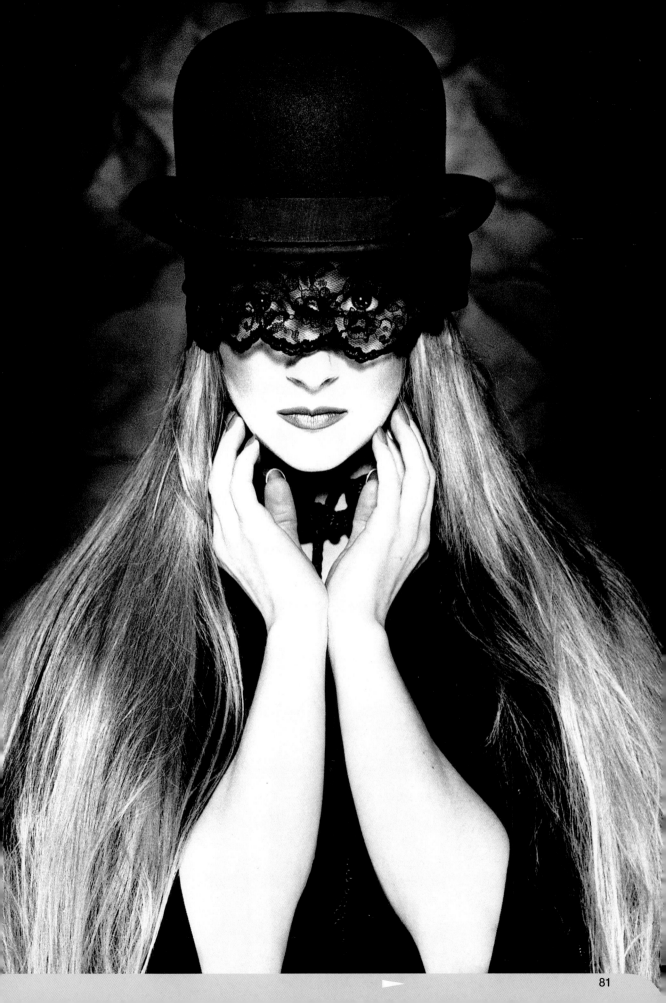

STILL
LIFE
04

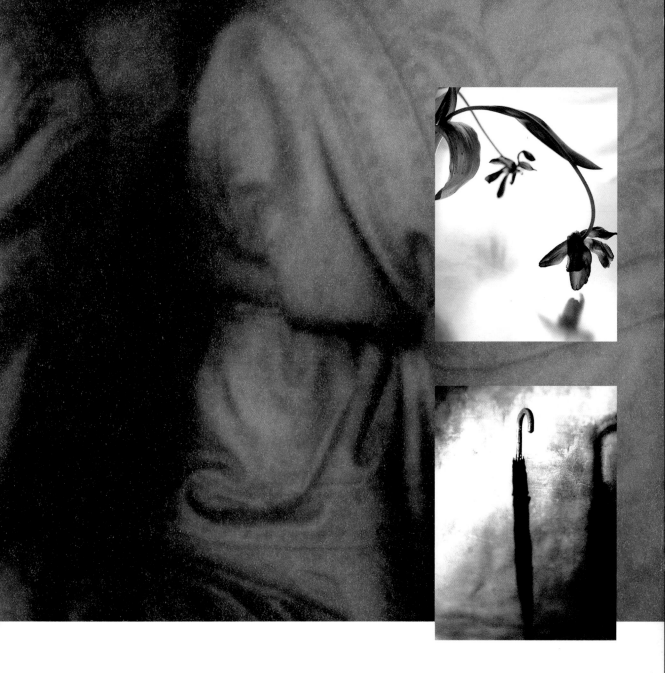

Still life can suggest a narrow-ranging and predictable art form. Yet the possibilities are endless: it can be humourous and quirky or cool and serene; it can convey peacefulness, elegance or morbidity; it can relate to the other arts, reflect a narrative, carry symbolism or it can simply be aesthetically pleasing. This selection of shots demonstrates the variety of approaches that are being explored in this exciting area. The still life is regarded as something of a traditional set-piece, and as with any well-defined genre the excitement lies in finding new approaches to a familiar brief.

While many of the shots here are table-top set-ups – and some even feature the traditional fruit and flowers often associated with classical still life – others explore some unexpected and surprisingly mundane subjects. Antonio Traza, for example, takes a new look at the humble umbrella, while Annella Birkett uses a simple bottle as the centrepiece for a highly theorised work that draws its influence from a literary source.

LILIES

photographer **Ray Spence**

use	Personal
camera	6x7cm
lens	90mm
film	Ilford FP4
exposure	1/8 second at f/11
lighting	Light box

The botanical diagrams of eighteenth and nineteenth century scientific text books are brought to mind here. The cool, factual portrayal of intrinsically graphic flowers has the look of a study of natural form; an annotated key to parts would not seem out of place.

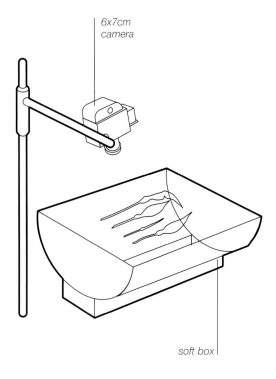

6x7cm camera

soft box

plan view

key points

Have a good supply of fresh subjects when working with cut flowers, which can wilt surprisingly quickly in studio conditions. Remove them from water at the last possible moment

Be aware of plant toxicity and allergy issues!

The three-dimensional shape is well revealed by the modelling. The flowers are positioned on a soft box so they are basically back- and trans-illuminated, and so the parts that are nearest to the camera (and furthest from the light box) demonstrate fall-off that defines the exact curvature of the shape.

The translucent quality of the plants – notice particularly the petal at the top left of the image – allows the internal structures to be viewed: the veins are quite clearly visible when back-lit in this way.

photographer's comment
The light box revealed both the form and translucency of the flowers.

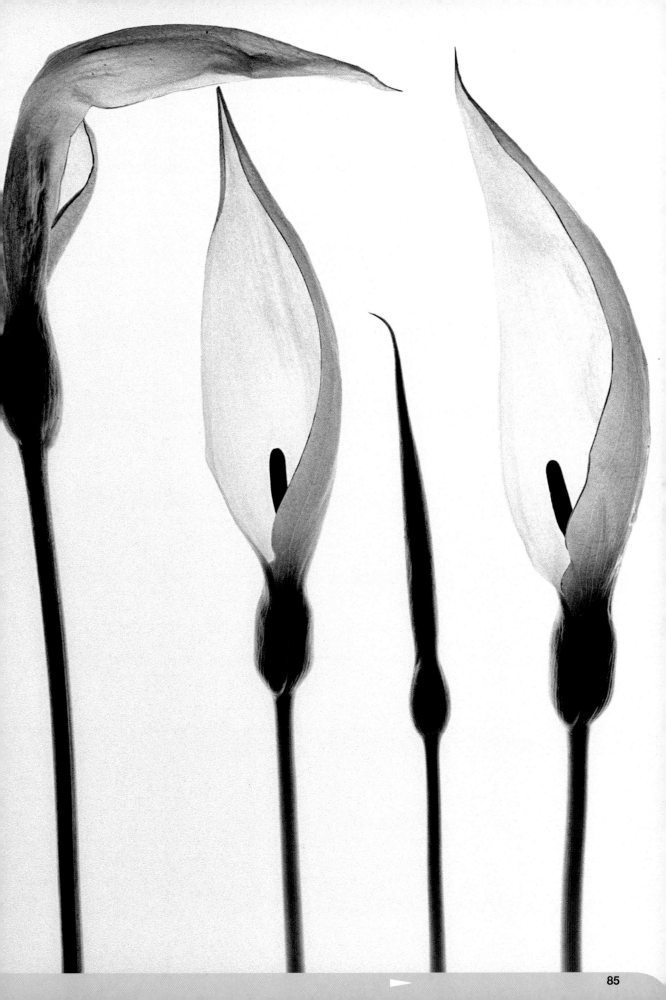

UMBRELLA

photographer **Antonio Traza**

use	Portfolio
camera	4x5 inch
lens	210mm
film	Polaroid 55
exposure	1/8 second at f/8
lighting	Tungsten
props and	
background	Hand-painted background

"Shadows often give you the impression of transcendence," says photographer Antonio Traza. **"I wanted deep directional shadows to play a part in the picture with the subject. I was looking for an effect, more than details in the object."**

plan view

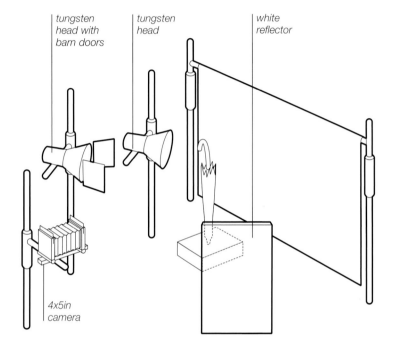

tungsten head with barn doors

tungsten head

white reflector

4x5in camera

key points

A variety of armatures are useful to have about the studio for supporting awkward subjects

Movements on large format cameras are worth investigating and experimenting with for a look verging on the surreal

Accordingly Antonio used two 2000-watt tungsten lights, both on the left of the camera. The first illuminates the background, which has been painted by hand to give a mottled, textured surface. This provides areas of grey at the top left and bottom right of the composition and an area of light diagonally through the frame against which the umbrella stands out. The second head illuminates the umbrella, causing the all-important shadow. This shadow is not sharp although the shape of the umbrella is clear to see. A reflector on the right provides fill.

photographer's comment

This shot was for a series I was doing for my portfolio on home objects. I wanted them to be recognisable but not defined so I tilted the back of the 4x5-inch camera to get the out-of-focus effect as well as using strong lighting to create the second element that is the shadow. The film, Polaroid 55, gives you a lot to play with and prints beautifully. It was printed on Kentmere art classic which is similar to watercolour paper.

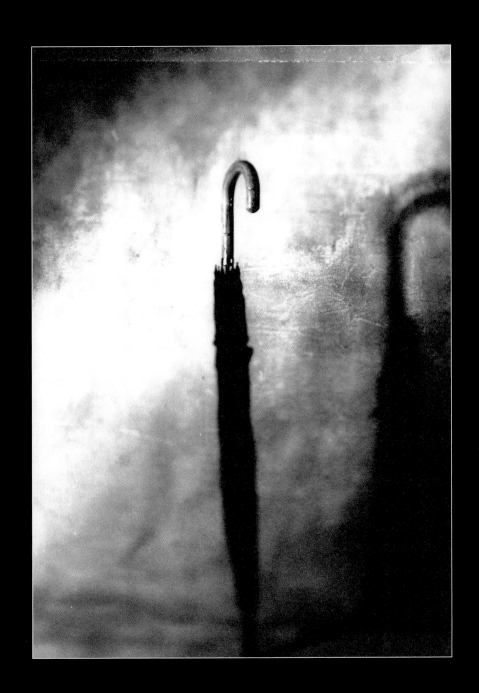

PEARS

photographer **Caroline Hyman**

The grainy look of this botanical-style study harks back to the tradition of artistic etchings.

use	Personal work
camera	6x6cm
lens	80mm
film	Agfa APX 100
exposure	Not recorded
lighting	Available light
background	Hand-made Japanese paper

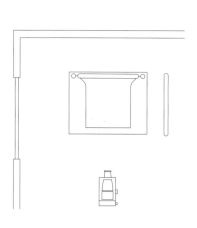

plan view

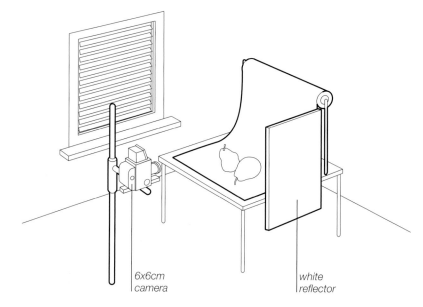

6x6cm
camera

white
reflector

key points

Texture can be introduced to an image by printing on to specialist photographic paper or by sensitising textured paper

Vignette printing can give a period look and add to a painterly feel

It would be possible to believe that this image originates as a pen and ink or even a charcoal drawing, with its emphasis on textural quality, its crisp edges and smudged surface rendition. Look at the well-defined upper edge of the pear on the left next to the stalk, for instance, or the dark blush area of the pear on the right, resembling a charcoal smudging technique.

However, a photograph it is, and a simply lit one at that. The key light comes from a large window, 8x6 feet, to camera left. Venetian blinds over the window act as a honeycomb, making soft light a little more directional to give a good sense of modelling across the curves.

A white reflector on the right of the table completes the set-up, providing some fill.

photographer's comment

To capture a photographic impression of etching.

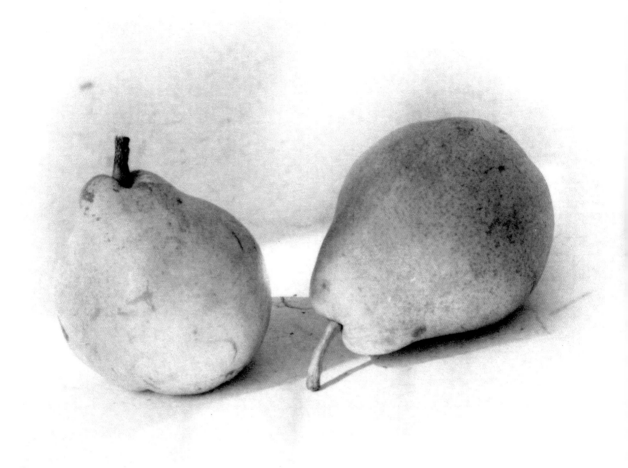

BETTER DAYS PAST

photographer **Kathleen Harcom**

use	Portfolio
camera	645
lens	100mm
film	Agfapan APX 25
exposure	1/30 second at f/8
lighting	Available light plus reflector

The window frame and shelf were removed from their original location – a dilapidated old shed covered with ivy and cobwebs – and were placed in a more convenient location for the shoot, outdoors in a sheltered spot by an evergreen hedge.

reflector

645 camera

plan view

key points

A sheltered, breeze-free site is essential when working at an outdoor location with fragile props such as petals or feathers

This natural lighting set-up could be emulated in the studio

The only light was the available daylight, with the sun to camera right. Although the sun was shining in a cloudless sky at the time, direct sunlight on the subject is diffused by trees. A reflector to camera left was angled to add a hint of glow and sparkle to the vase and flowers.

This is a shot where time-consuming preparation must be considered ahead of the shoot. The composition was planned beforehand and the sunflowers had been kept in the vase indoors for some days before the shoot to allow them to die off and collapse naturally. Fallen petals were kept to be included in the final arrangement.

photographer's comment

Harmony is important within a still life. The elements of the picture have to be sympathetic to each other and the old window presented a wonderful foil for the vase and dying flowers. I needed the final element, the lighting, to be soft and sensitive to the character of this subject.

FEET KISSING

photographer **Tim Ridley**

use	Personal work
camera	35mm
lens	35mm
film	Ilford FP4
exposure	1/60 second at f/5.6
lighting	Available light

This freestanding plaster-of-Paris reproduction statue was displayed in a large gallery space with a 50-metre window along one side.

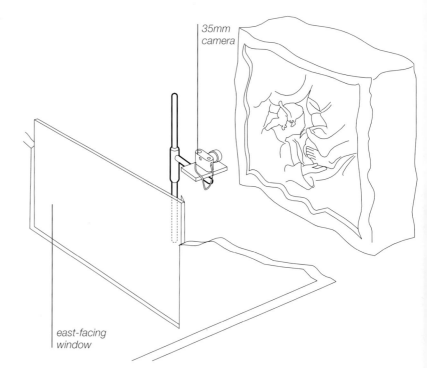

35mm camera

east-facing window

plan view

key points

Light from the east varies enormously through the course of the day and it is important to take this into account when planning a shoot

A gallery's permission must always be sought before taking commercial photographs of artworks

The window let in light from the east on a slightly hazy day. The photographer stood with his back to the huge window, and the soft diffuse light illuminated the subject without directionality. The statue itself was a considerable distance from the window.

Under these circumstances, a good amount of modelling shadow registers, and the sculpted surface is revealed. Notice the shadow behind the fingers holding the lower foot, for example. The sculpted subject with its many nooks and crannies provides plenty of opportunities for further play of light and shade.

Finally the image was printed on textured paper.

DEAD TULIPS

photographer **Annella Birkett**

use	Personal work
camera	6x6cm
lens	110mm
film	Ilford FP4 rated at 80 ISO
exposure	1/250 second at f/4
lighting	Available light and electronic flash
background	Draped sheet

The main light source is diffused daylight from behind the subject and round slightly to the right of the camera. The thin white fabric draped across the window acts as a backdrop as well as diffusion material – notice in the background the billowing swathes evident at the top right of the frame.

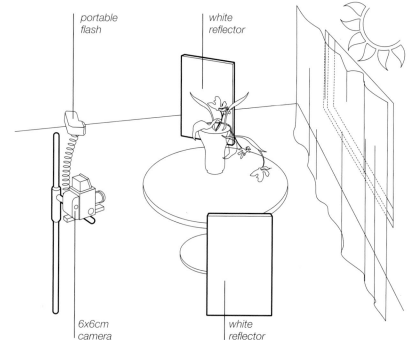

portable flash

white reflector

6x6cm camera

white reflector

plan view

key points

The flower on the left demonstrates the ghostly look that can be achieved by combining selective focus with back-lighting of a translucent subject

You don't have to photograph flowers in colour to get the best out of them. Photographing in black and white can inspire a sculptural quality easily overlooked in colour work

There are reflectors on two sides, and frontal fill comes from a diffused Metz hammerhead flash.

The exposure was determined by taking a spot meter reading from the shadows. A large aperture was deliberately chosen to minimise the depth of field and give the partial focus look.

The camera is positioned in relation to the window source in such a way as to incorporate the shadows of the subject on the table top into the overall composition. They even seem to take on the appearance of reflections in their respective positions, since the translucence of the petals allows a certain amount of detail to register in the shadow areas.

photographer's comment

I wanted both the tissue paper texture of the dead petals and the rococo curves but with a high-key effect emphasising the fragility of the flowers.

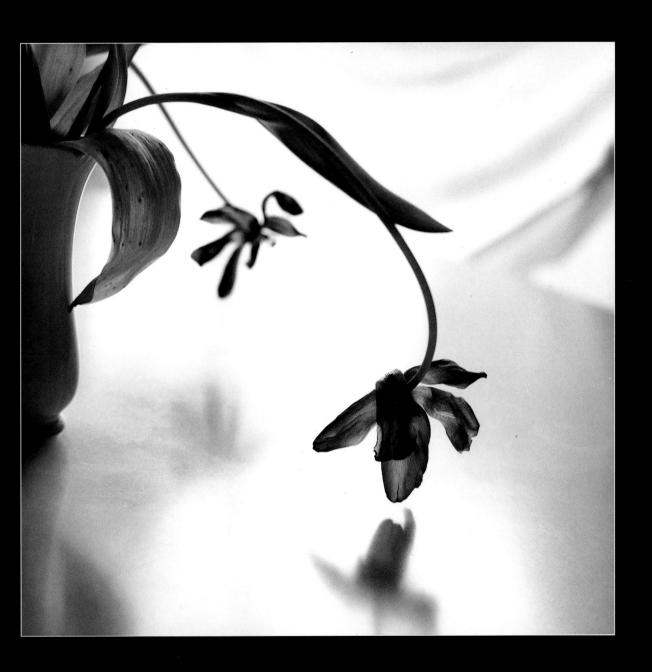

LADY OF SHALOTT

photographer **Annella Birkett**

use	Personal work
camera	6x6cm
lens	110mm
film	Fuji Reala printed in black and white
exposure	f/8
lighting	Tungsten and electronic flash
background	Diffusion fabric

Annella Birkett describes the set-up here as being like a theatre with a floor, ceiling with overhead lighting, a background, and two side walls.

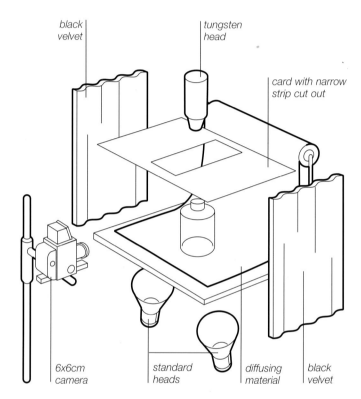

black velvet | tungsten head | card with narrow strip cut out

6x6cm camera | standard heads | diffusing material | black velvet

plan view

key points

Literary sources can provide imaginative stimulus for fine art work

Good control of highlights on glass surfaces can be achieved by careful positioning of lights coupled with careful flagging

The bottle is centre stage with black velvet drapes acting as the side walls to prevent unwanted reflections. The ceiling is a card with a small slit, allowing in limited light from above to control the hot spots around the shoulder of the bottle very precisely. The stage floor is a glass tabletop covered with diffusing material, and two standard heads supply the main lighting from beneath the glass. Finally, the background is a continuation of the diffusing material. The image of the foot within the bottle is a worked-on photocopy onto acetate of a photograph.

The shot is part of a series exploring the underlying themes of Tennyson's poem "The Lady of Shalott". Each picture relates to an aspect of the Lady's (and womankind's) restricted existence, unable to go anywhere, to do very much, to see the world or to communicate directly. This particular image picks up the theme of the Lady's immobility and enclosure.

photographer's comment

This was shot in colour, but the series is all in monochrome except for some small coloured highlights. A very highly theorised work. A single word for what I wanted the series to convey would be 'containment'.

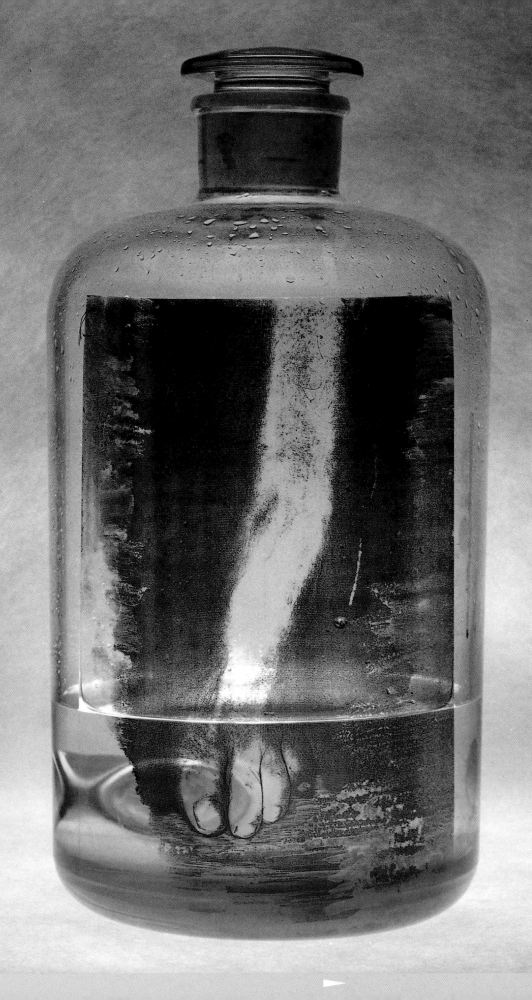

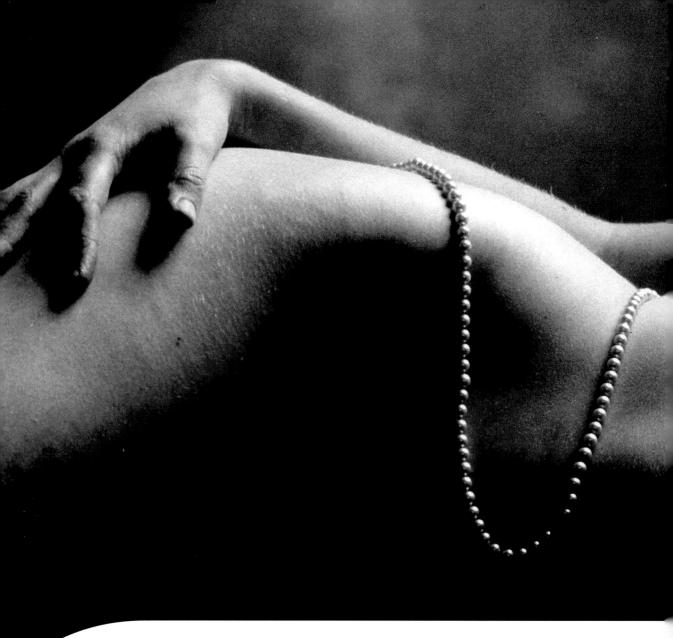

NUDES

05

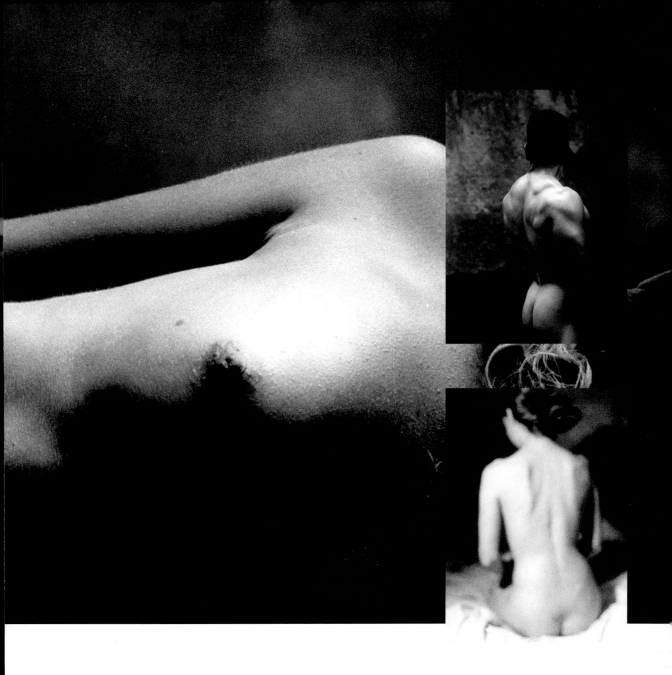

It is no accident that a good half of the shots featured in this chapter were taken on location, using daylight as the main source. Not only does the nude as a subject often work well in a natural location setting, but sunlight can be the perfect natural source to complete the exploration of the human form.

In the studio, the nude is perhaps the most popular fine art subject, and study of the nude form is of course the starting point for figurative artists of all kinds. Experimentation with lighting can reveal the many facets of the human form, emphasising certain features over others, and so a considerable diversity of studio set-ups, unsurprisingly, are represented in the studio shots in this chapter.

The subject of the nude has an age-old fascination for the artist. The play of light on the human body is a subject that artists never exhaust, and, it seems, is a subject that we never tire of looking at.

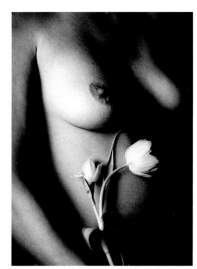

LUCIE

photographer **Gianni Russo**

use	Portfolio
model	Lucie
camera	35mm
lens	85mm
film	Tmax 100
exposure	1/60 second at f/4
lighting	Tungsten
props and	
background	Black paper background

Precariously perching up a step ladder, with the model reclining on the floor beneath, Gianni Russo has found the perfect vantage point to capture the drama of this pose. The all-important element of interest in the composition is shadow, carefully controlled to give definition to the areas of greatest interest.

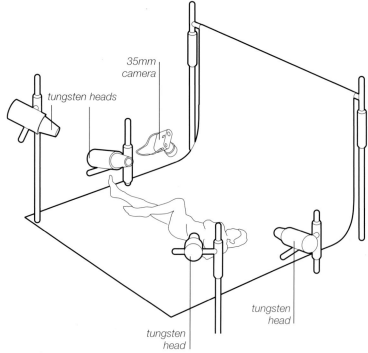

35mm camera

tungsten heads

tungsten head

tungsten head

plan view

key points

Be aware of safety issues when seeking unusual vantage points in the studio

Fine lines of shadow can be used to good effect to define the edges and form of the subject where bright, even lighting is in use overall

Four 500-watt heads were used. Two of these were placed high up above the reclining model, one to camera left to give general overall illumination, and one placed to camera right and crucially just behind the model. This provides the fine line of shadow below the breast and the broader area of shade across the upper shoulder, which gives some separation from the chin line.

The two heads low down behind the model serve to lift the background (i.e. the floor) a little and, in the case of the one to camera right, to backlight the model's hair.

photographer's comment

I elaborated upon this image in the darkroom.

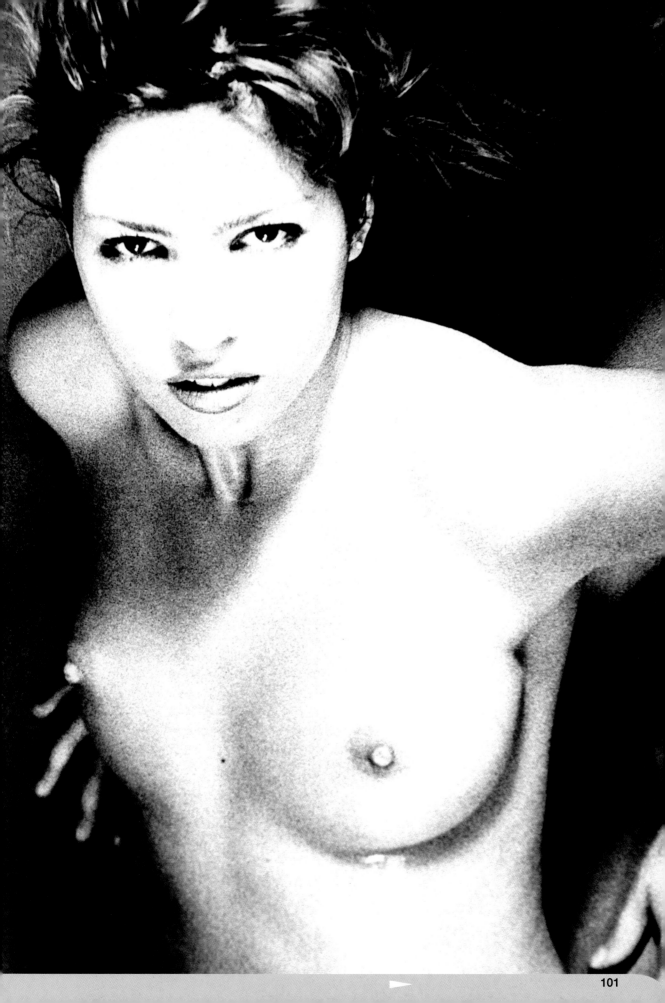

GIRL'S BACK

photographer **Antonio Traza**

use	Portfolio
camera	6x7cm
lens	127mm
film	Ilford FP4
exposure	1/60 second at f/5.6
lighting	Tungsten
props and background	Painted background and bed

plan view

It is interesting to compare this shot with Holly Stewart's "Regina".

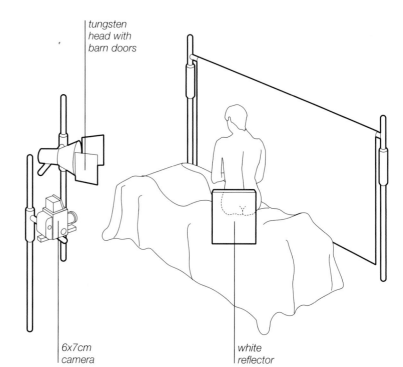

tungsten head with barn doors

6x7cm camera

white reflector

key points

Fashion applies in photographic technique as in all other areas of artistic endeavour. A noticeable trend in recent times has been the exploration of the artistic possibilities of de-focusing – not to be confused with uncontrolled, careless out-of-focus effects

An alternative method of softening the focus is to smear petroleum jelly on a clear filter over the (correctly focused) lens

Whereas Holly Stewart chose selective focusing to give sharpness to the model's eyes while allowing the rest of the subject to remain soft, Antonio Traza here demonstrates the effectiveness of allowing the whole area of the image to be out of focus in order to emphasise form rather than detail.

"I wanted a picture that showed the beauty of the girl's back and I decided to do it out of focus so only general forms were apparent. This reduction of clarity gave a softness to the skin," he explains. The lighting set-up of a 2 kw tungsten head to camera left and a relatively small reflector close to the model to camera right accentuates the forms in the back by allowing just enough of the shape to be defined by soft lines of shadow.

photographer's comment

I love this type of lighting. It is ideal if anyone wants shadows to play a part in the picture. One light and a reflector are placed in the right positions. It is just enough to get a good picture.

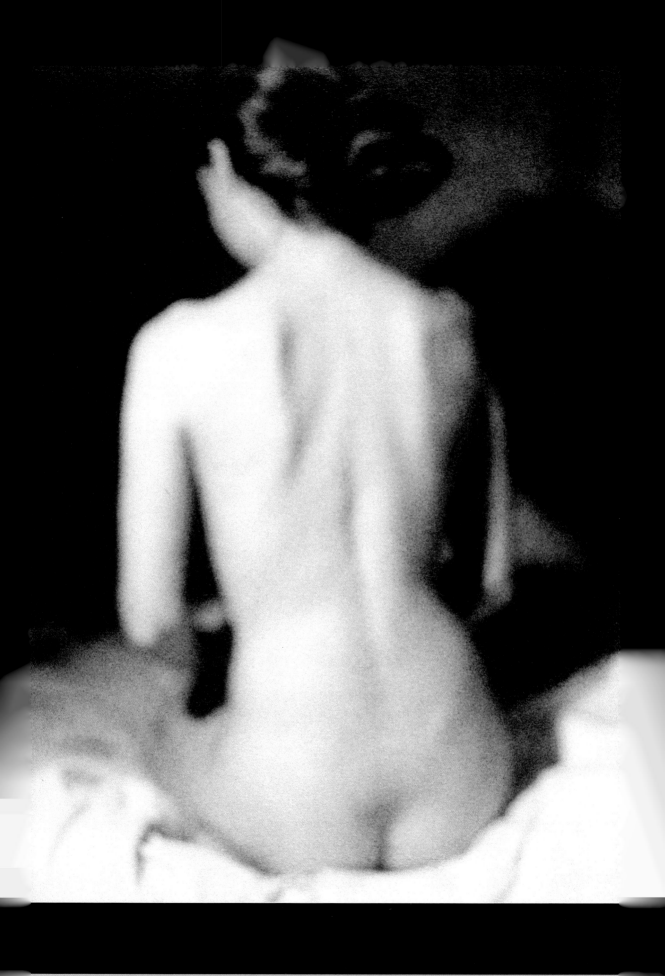

BODY

photographer **Ben Lagunas**

client	Private art gallery
use	Gallery
assistants	Pauline, Laura
art director	Ben Lagunas
stylist	Vincent St Angelou
camera	6x6cm
lens	210mm
film	Tmax 100
exposure	1/125 second at f/8
lighting	Available light

Although the diagram for this shot indicates a considerable number of items of lighting equipment, it is interesting to note that in fact none of them are lights.

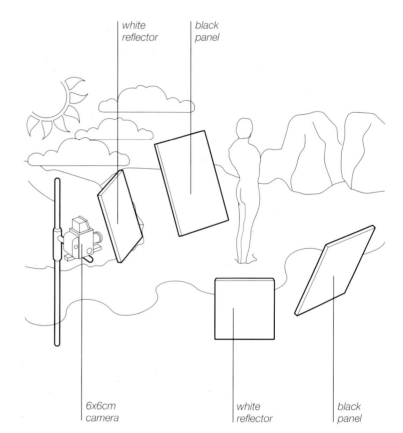

white reflector
black panel

6x6cm camera
white reflector
black panel

plan view

key points

Make the most of well-defined muscular tone by using relatively directional lighting that will emphasise the rippling contours

What is concealed is as important for visual impact as what is revealed in some instances

In the same way that an artificial key light might be modified, so the sun has been modified by an array of black and white bounces on both sides of the camera. It is a bright day with passing cloud on location in Mexico, and the sun is almost directly overhead. The model stands between two large black panels that emphasise fall-off across the contours of the body, while two frontal white bounces lift the shadows and create a variety of highlights.

A red filter used over the camera lens also plays a part in controlling the lighting look of the final image by increasing contrast.

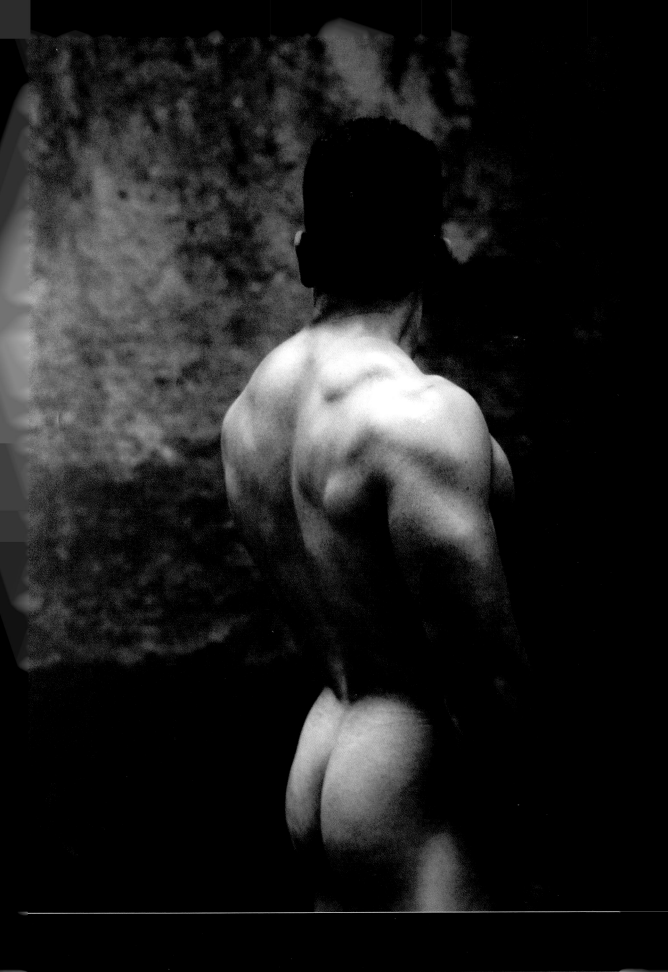

LUNA

photographer **Wolfgang Freithof**

use	Personal use
model	Luna Mohammed
stylist	Sophia Lee
camera	35mm
lens	85mm
film	Ilford XP2
exposure	Not recorded
lighting	Available light

This shot was taken in the late afternoon at the end of a working day on an editorial shoot.

reflector

35mm camera

reflector

plan view

key points

When cross-processing XP2, the transparencies can be given a blue or green hue. Experiment with different film ratings to achieve the desired result

Sand on the body can be used to introduce separation

The model wanted some additional pictures for her own personal use and so the stylist arranged a simple length of fabric into an improvised bikini, and the model, adorned only in a turban, a loin cloth and some sand, was ready.

Available light may not fall exactly how it is wanted, and a range of reflectors and diffusers can always be introduced to modify the sunlight. In this instance the photographer used an 8x8-foot diffusion silk, mounted on a pair of stands, placed between the sun and the subject, and added a reflector on either side, thus bathing the model in all-round soft light.

The XP2 film stock was processed in E6 chemistry to give a black and white transparency.

photographer's comment
This is one of my favourite images. I keep returning to it and putting it back into my portfolio.

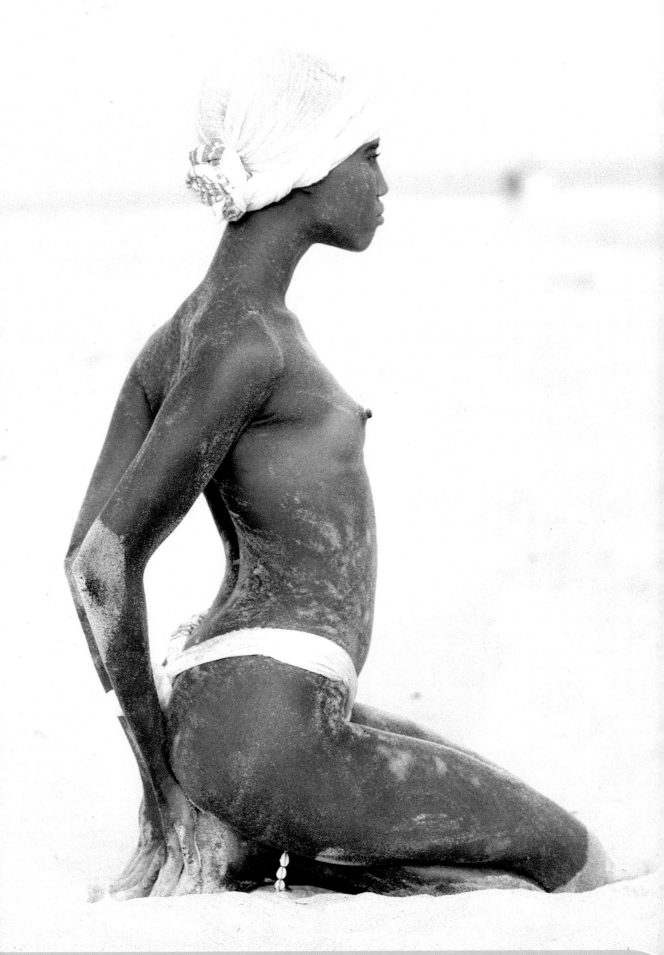

ADONIS

photographer **Ben Lagunas**

client	Private art
use	Gallery
assistants	Pauline, Isak
art director	Ben Lagunas
stylist	Fabian Montana
camera	6x6cm
lens	210mm
film	Tmax CN
exposure	1/60 second at f/16
lighting	Available light

The very name of Adonis, who according to Greek mythology was a youth beloved by Venus, is short-hand in modern life for a paragon of beauty and physical perfection.

plan view

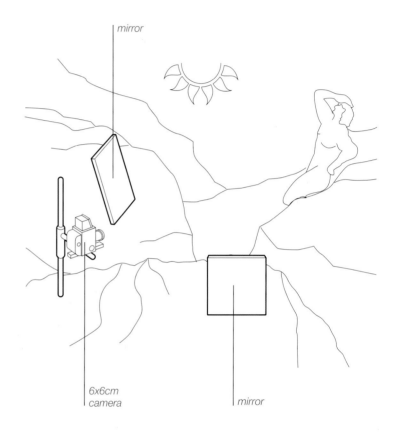

mirror

6x6cm camera

mirror

key points

Ancient myths can provide good inspiration for contemporary imagery

Keep a note of interesting locations when you happen across them for future reference

As interpreted here by Ben Lagunas, this latter-day Adonis basks in the sunlight beneath the open skies, clad only in discreetly contrived shadows.

The model's gleaming physique is emphasised by the strong shadows resulting from the high angle of the sun. The foreground offers similarly rugged textures. The light plays on the crevices

and is filled somewhat by the mirrors either side of the camera.

The relatively low-contrast appearance – notice how the blacks of the shadows are not really black at all – can be attributed to the choice of film. Tmax CN is a black and white stock that can be processed in C41 chemistry to achieve this distinctive look.

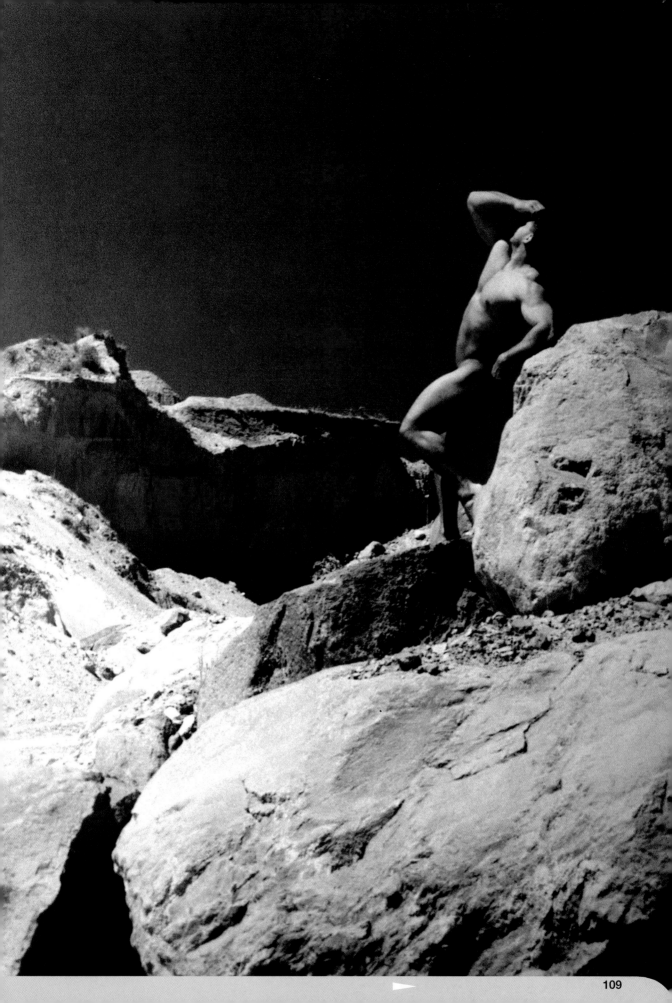

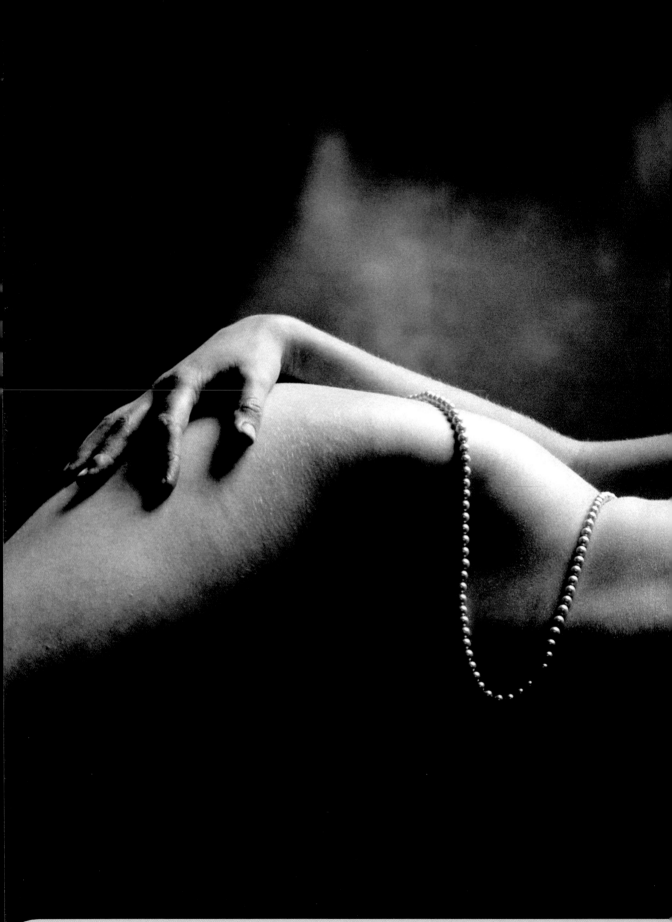

NUDES

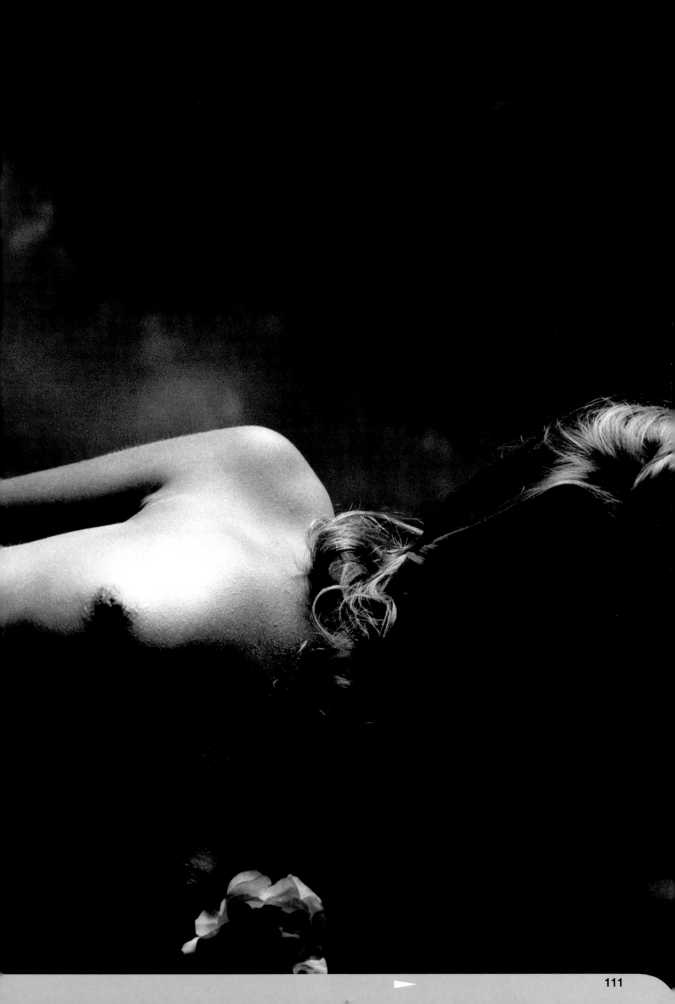

KELLY

photographer **Björn Thomassen**

client	Kelly
use	Portfolio
model	Kelly
camera	645
lens	100mm
film	Tmax 100
exposure	1/250 second at f/11
lighting	Electronic flash

The model posed on a bench, and was draped with the string of pearls for additional interest and to provide some relief from mid-tones, while the purpose of the flower in the foreground was to give additional depth.

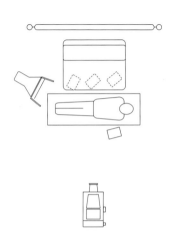

plan view

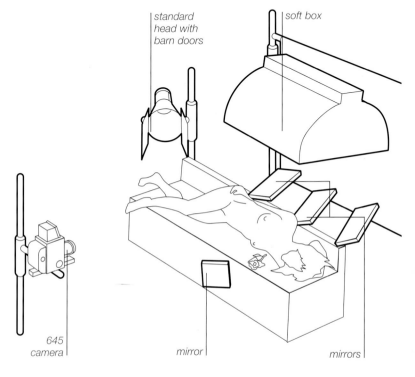

standard head with barn doors

soft box

645 camera

mirror

mirrors

key points

Mirrors can be used to place light quite precisely. The size and shape of the mirror will determine the scope of the resulting light beam

Using light as only a minority component of the composition can give a powerful visual impact

The main light was a 5-foot soft box above and slightly behind the model. The light was directed so as to cast a shadow over the face, thus increasing the feeling of mystery.

A standard head with barn doors placed near the model's feet was aimed towards the background and angled downwards to catch a series of mirrors positioned at different angles on the floor behind the model. These reflected a spattering of light patches to add interest and texture on the background.

Another small mirror was used to reflect light from the overhead soft box onto the flower.

The model was lying on black velvet, and this allowed the base of the picture to go black.

CLIMAX

photographer **Ben Lagunas**

Popular wisdom has it that shooting with the camera facing towards direct sunlight is a bad idea. Ben Lagunas, however, shows that an excellent result is possible if the photographer fully comprehends the parameters of such a set-up.

client	Private art
use	Gallery
assistants	Pauline, Christian
art director	Ben Lagunas
stylist	Fabian Montana
camera	6x6cm
lens	210mm
film	Tmax 100
exposure	1/60 second at f/11
lighting	Available light

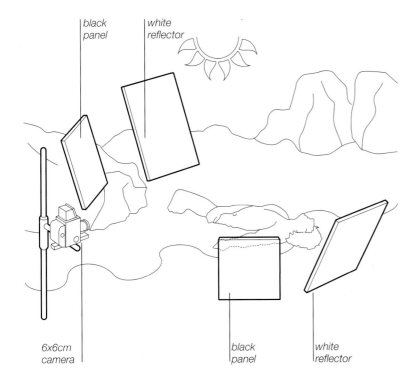

black panel

white reflector

6x6cm camera

black panel

white reflector

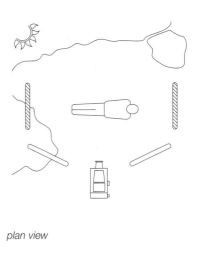

plan view

What is crucial for this success is an understanding of how to make a low-key subject work against a high-key background area, and how to avoid unwanted flare when shooting towards the sun. Here, the photographer flags appropriately for what is an effectively back-lit composition, or at least a composition lit decidedly from behind. The two black panels placed between the model and the camera serve the dual purpose of flagging light from the lens and keeping the front of the subject low key. There are white panels either side of the model which reduce the contrast a little. The near side surfaces of the model thus remain shadowy, with strong fall-off from the upper sunlit surfaces.

key points

Safety is all-important when shooting in potentially dangerous locations; be sure of the environs before you start

Water – especially moving water – makes a wonderful subject and a wonderful fluid reflector

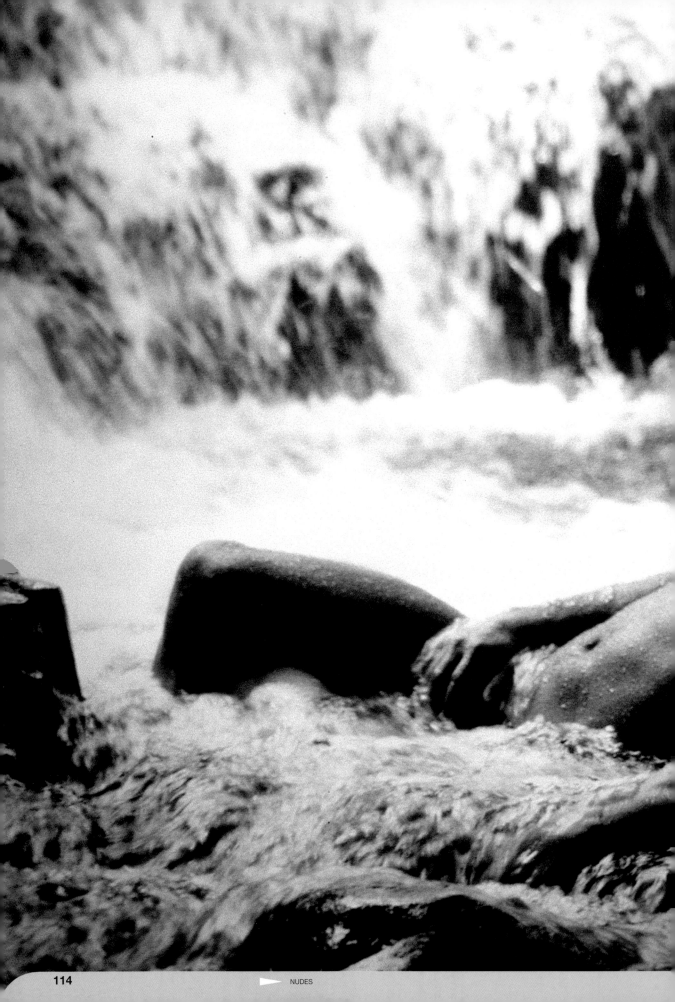

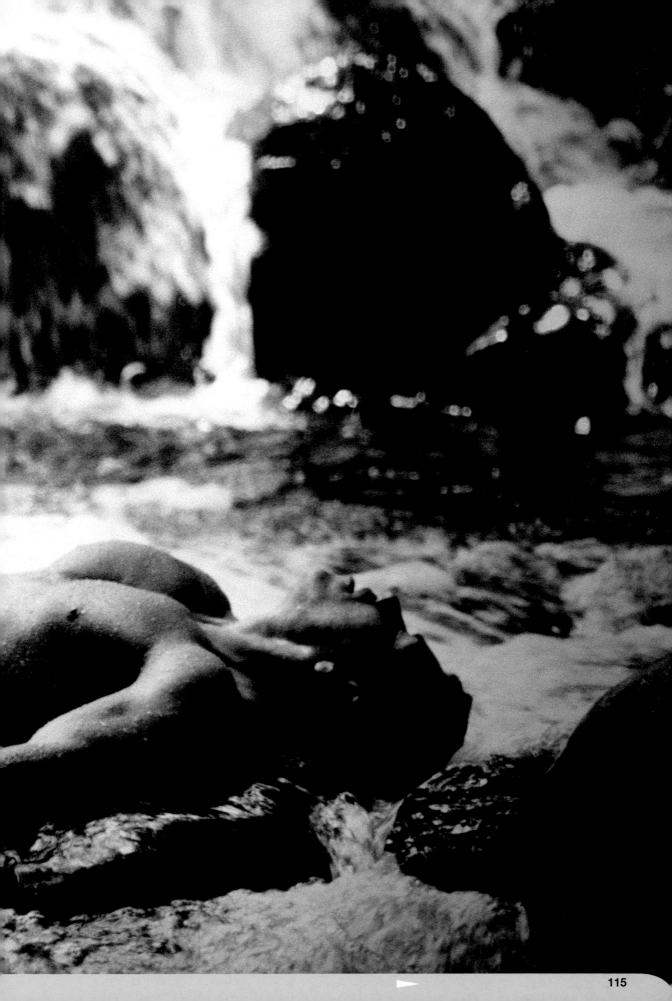

TULIPS

photographer **Ray Spence**

use	Personal
model	Sue
camera	6x7cm
lens	90mm
film	Ilford FP4
exposure	1/15 second at f/8
lighting	Tungsten

This shot explores curvatures of various kinds. The crook of the arm, the gently bowing tulip stem and the curve of the breast and hip are carefully juxtaposed to good effect.

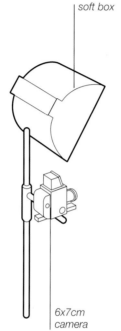

soft box

6x7cm
camera

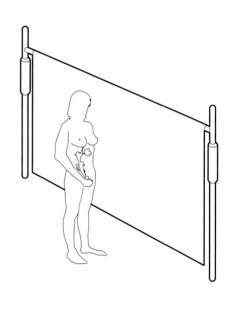

plan view

key points

Directing the model well is extremely important when every detail of the pose counts

Chiaroscuro gives a dramatic, painterly feel to an image, and a very striking end result

The model cradles the tulip whose flower head is at the exact centre of the composition, and which gleams out to surprising degree. This luminosity occurs because the flower petals are true white, against the soft skin tones of the model's body. All are lit equally by the soft box, but the effects are startlingly different on the disparate elements of the subject.

The image is exposed to ensure good modelling and range of tones across the model's body, but this results in slight over-exposure in relation to the white flower head, again contributing to its dazzling appearance. Only the modelling light is used.

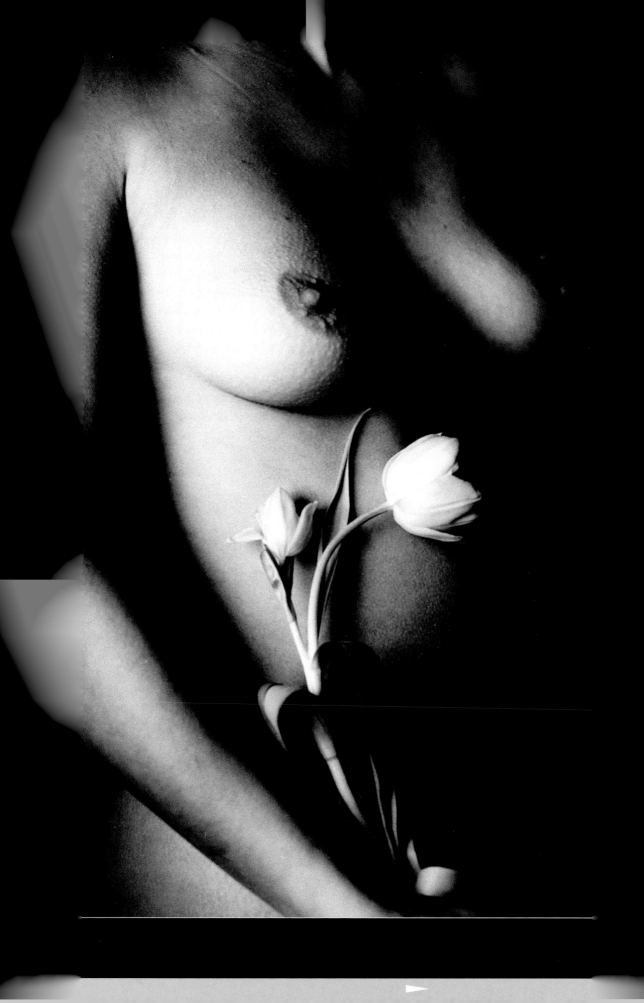

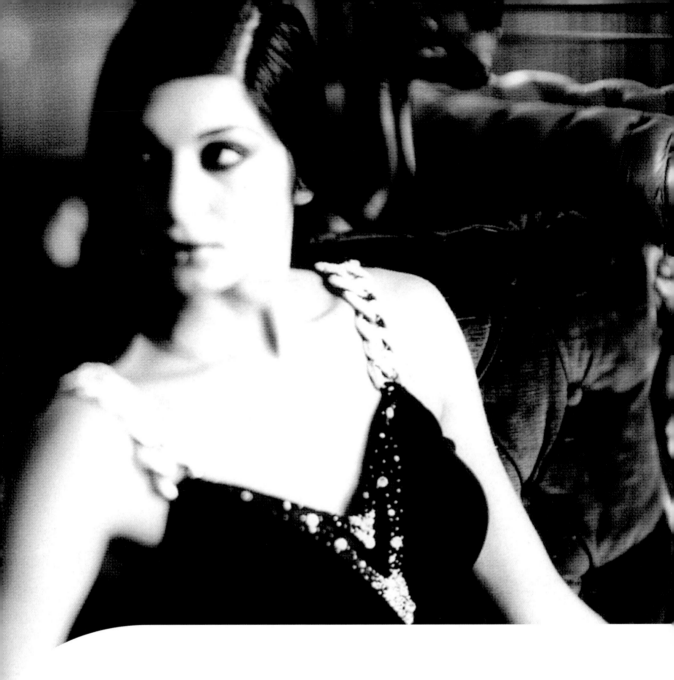

ADVERTISING and PROMOTION

06

In advertising work, the important thing is to convey the essence of the product being promoted, in order to stimulate the 'must-have' instinct in the consumer. This does not necessarily mean photographing every detail in a clinical or documentary style. The peripheral factors of setting, styling, mood and hinted-at lifestyle are just as important as the product itself in terms of the impression they convey. For this reason, the atmospheric quality of black and white is often a preferred choice over naturalistic full colour rendition. The atmosphere is more persuasive than an account of every last detail of the product.

Identifying the target audience is the first consideration, and the client's advertising agency, art director, sales and marketing departments, as well as the photographer, will all have a view. The expertise that the photographer brings to the actual shoot is artistic, practical and professional: to know how to light and create the mood desired, and to realise the concept that so many will have spent time and effort devising.

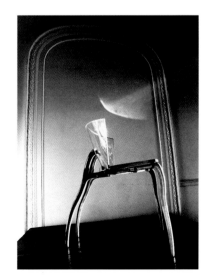

BAGATELLE COUTURE 1

photographer **Salvio Parisi**

client	Bagatelle Women's Couture
use	Advertising campaign
model	Paola Mercurio
assistant	Chicca Fusco
art director	Gazia de Angelis
make-up	
and hair	Francesco Riva
camera	4x5 inch
lens	150mm
film	Tmax 100
exposure	1/60 second at f/5.6
lighting	Available light and
	electronic flash
props and	
background	Parker's Hotel Hall,
	Naples, Italy

plan view

"The requirement in this picture was to show off some detail of Bagatelle's evening dresses in an elegant black and white atmosphere," comments photographer Salvio Parisi.

4x5in camera

soft box

key points

Shooting on location in a commercial or private setting may take a great deal of pre-arranging, especially if 'business as usual' has to be observed during the shoot

Leads and other equipment must be arranged carefully so as not to endanger any members of the public at an open location

He used a large-format camera, and swung the lens vertically with a large aperture to obtain the short focus effect on the detail. The effect of this in the final shot is quite clear. The camera movements are pivoted along the vertical axis, so the plane of focus is diagonal across the frame and the right side of the composition is thus deliberately de-focused, while the model and the left side of the shot are in sharper detail.

To the right of the camera is an upright 70x170cm soft box, supplying fill along the full length of the model. The key light, though, is the daylight flooding into the location through the glass revolving doors and windows, giving the gleam across the polished floor and on the model's back.

ADVERTISING AND PROMOTION

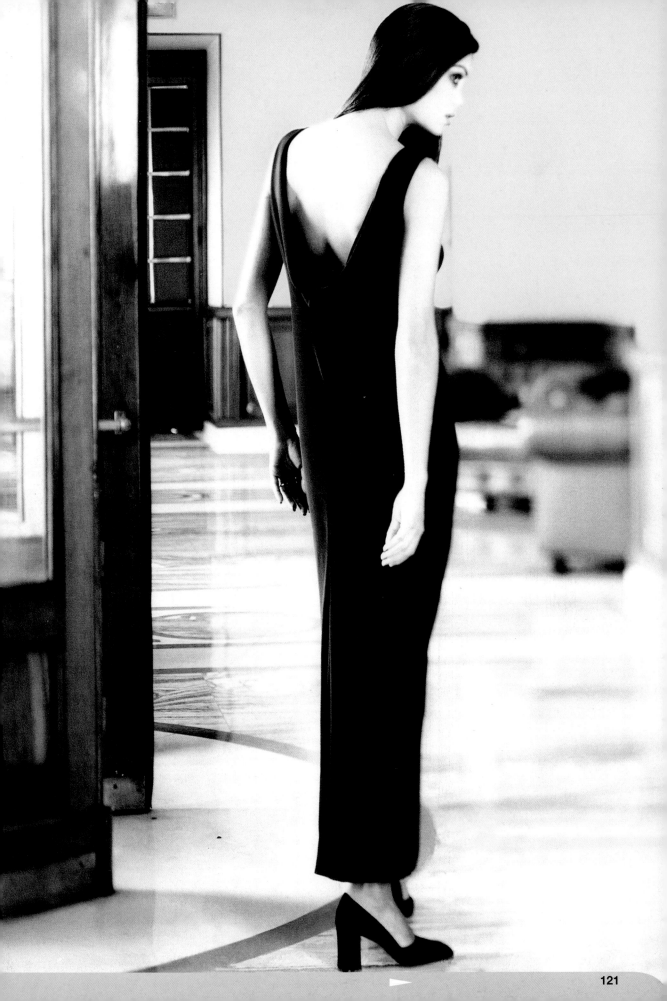

SINK

photographer **Steve Speller**

client	FX Magazine
use	Supplement cover
stylist	Steven Speller
camera	35mm
lens	50mm
film	Fuji Neopan 1600
exposure	1/15 second at f/16
lighting	Tungsten

This strong and stylish image was commissioned for the cover shot of an equally stylish lifestyle magazine supplement to represent a feature on contemporary kitchens and bathrooms.

plan view

key points

Shiny metal surfaces such as chrome will reflect focused light. Matt metal surfaces such as this kind of finish of stainless steel will reflect diffused light

A pipette is a convenient way of positioning liquid props with some degree of precision

Because of the dual element of the article subject, it was important that the image should be somewhat ambiguous about its subject too: is it a kitchen sink or a bath?

The carefully arranged water droplets were intended as a focus of interest for the image. The modelling light of a single standard head was used to shoot into a silver umbrella and bounced from behind the subject. This set-up accentuates the water droplets and helps to maximise the shiny finish of the hand-made designer stainless steel sink. The position of the crescent highlight around the edge of the plug hole indicates the relative position of the light.

The dark area to the lower right of frame is the result of the exact positioning of the light.

photographer's comment

Features hand-made "Subtle" stainless steel sink and an Arnie Jacobsen mixer tap.

UNTITLED

photographer **Robert Anderson**

client	Tovi
use	Advertising
model	Kendra Newton
art director	Tami Reman
stylist	Kim Khamus
camera	35mm
lens	200mm
film	Polaroid Polapan
exposure	1/2000 second at f/11
lighting	Ring flash with available light

The term "over-exposed" is often mistakenly understood to have a pejorative overtone. Yet so-called "correct" exposure is only a bench-mark guideline, and deliberately chosen deviations from it are equally legitimate and effective techniques to adopt, as Robert Anderson here demonstrates.

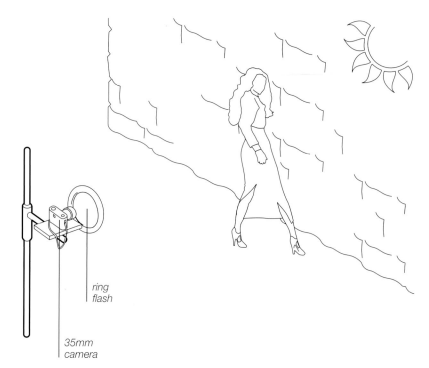

plan view

ring flash

35mm camera

key points

Learn to control all light within the scene. High shutter speeds with flash will knock down ambient light levels to the point where they are not contributing to the scene

It is well worth getting to know the latitudes of each type of film in order to get the exact look that you want

The sole additional lighting is in the form of a powerful ring flash set at f/22, which is two stops over the ambient reading of f/11 to which the camera is set. This gives the stark, high contrast look of this shot. Notice, for example, the flattering lack of detail in the complexion of the model and the over-lit look of the wall background. At the other extreme, there is no detail in the deep black of the skirt. However much light is pumped into it, it seems to give nothing back.

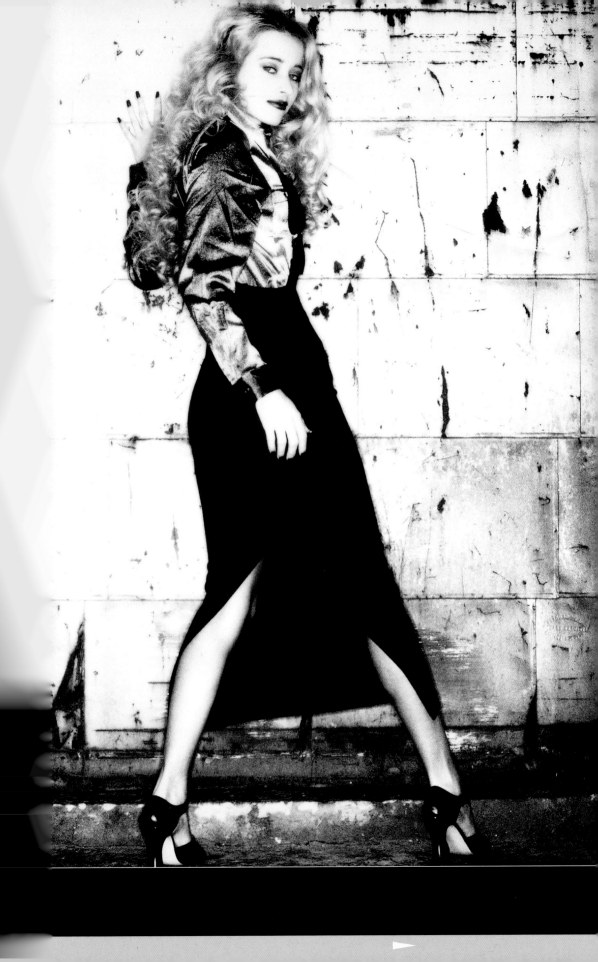

BAGATELLE COUTURE 2

photographer **Salvio Parisi**

The natural daylight from two large windows is supplemented by the use of a soft box. This is positioned between the windows quite close to the model.

t	Bagatelle Women's Couture
	Advertising campaign
el	Paola Mercurio
stant	Chicca Fusco
rector	Gazia de Angelis
e-up	
hair	Francesco Riva
era	4x5 inch
	150mm
	Tmax 100
sure	1/60 second at f/5.6
ing	Available light
	and electronic flash
s and	
ground	Parker's Hotel Hall,
	Naples, Italy

iew

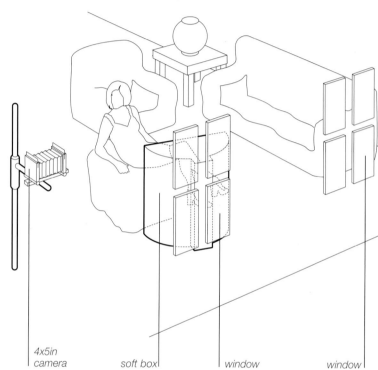

4x5in camera soft box window window

points

ell as making an extraordinary
ct in its own right, black velvet
extremely useful light-soaking
to use for backgrounds that
to be deep non-reflective black

on a bright day in sunny Italy,
ble daylight may need to be
nced by a soft box when
ng in an indoor location.
arch the location beforehand
nake no assumptions about
edictable factors such as
ble light levels

The light falls full on to the model, giving a bright, even look to the skin. The light provides just enough detail on the jewelled decoration of the gown to capture interest and give a good sense of the quality and luxurious style of the garment.

Interestingly, the relative lack of detail on the main body of the dress adds to the impression of its sheer luxury and quality. For all the light that is flooding the scene, the black dress shows remarkably little detail. The model is thus clearly swathed in a matt, unreflective fabric that can only be a heavy, rich, black velvet. The stiff edge of its hemline, demonstrated by the elegant but carefully chosen pose, confirms this.

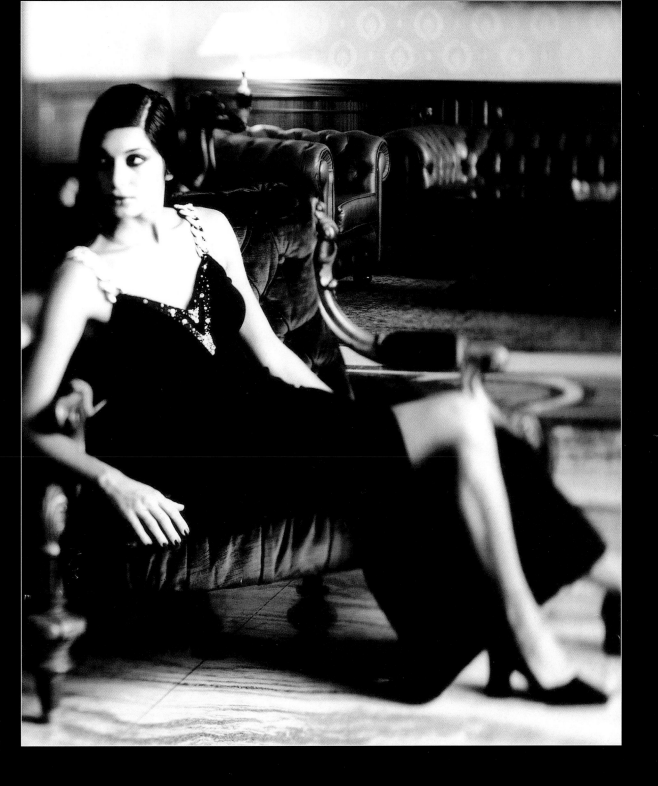

CHAIR

photographer **Steve Speller**

client	Simon Tyrell
use	Editorial
art director	Simon Tyrell
camera	645
lens	35mm
film	Agfapan 100
exposure	15 seconds at f/11
lighting	Available light

The exceptionally long exposure of 15 seconds is accounted for by the fact that this shot was illuminated by a light-painting technique in an otherwise dark room.

plan view

645
camera

mirror

key points

Light-painting provides an un-naturalistic style of lighting which can be very appropriate for artistic artifacts

When photographing furniture it is extremely important to compose the shot well to show off the form and style of the piece to good effect

The only source of light was a small beam of sunlight. Steve Speller used a small hand mirror to reflect the rays on to the chair to light-paint the shot. This is a similar technique to using a light brush but with much less flexibility.

The photographer distanced himself from the camera in order to be positioned appropriately to work with the sunbeam entering through the otherwise blacked-out window. The static position of the light source meant that movement was very limited with regard to the relation of the mirror to the beam.

The bright highlight beam is a deliberate light 'leak' allowed to register for interest and to echo the form of the curved chair back and to pick up on the transparency theme of the chair materials.

photographer's comment

The designer's own chair shot at the Royal College of Art, London.

DIAMONDS

photographer **Gérard de Saint-Maxent**

Not every photographer gets the opportunity to work with diamonds of this size and quality, but if the opportunity does arise, their gleaming crystalline form makes for exciting compositional and lighting possibilities.

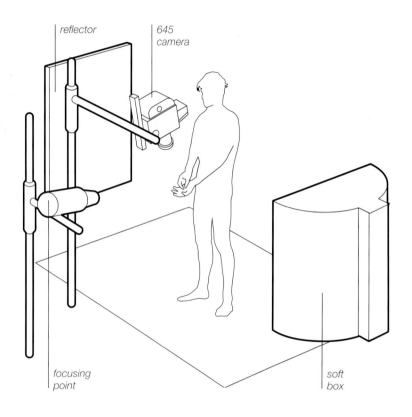

reflector

645 camera

focusing point

soft box

There is a soft box about two metres to the left of the subject with a reflector about three metres to the right. A projection spot is used to make a hot spot behind the hands to separate them from the mottled background.

The type of grain and softness of this image is characteristic of the Tmax film used. Nevertheless, the 'hero'

diamonds have a clarity and sharpness all of their own. They are, after all, light reflectors par excellence in their own right, and it is hardly surprising that against a setting of human skin and painted fabric, each with their intrinsically soft textures, the jewels should stand out so sharply.

use	Editorial
camera	645
lens	105–210mm
film	Tmax 400
exposure	1/60 second at f/8
lighting	Available light and electronic flash

key points

The focusing capacity of the projection spot allows good control over the definition of the hot spot

Working with black and white is all about getting the most out of contrast: of form and textures as much as tone

plan view

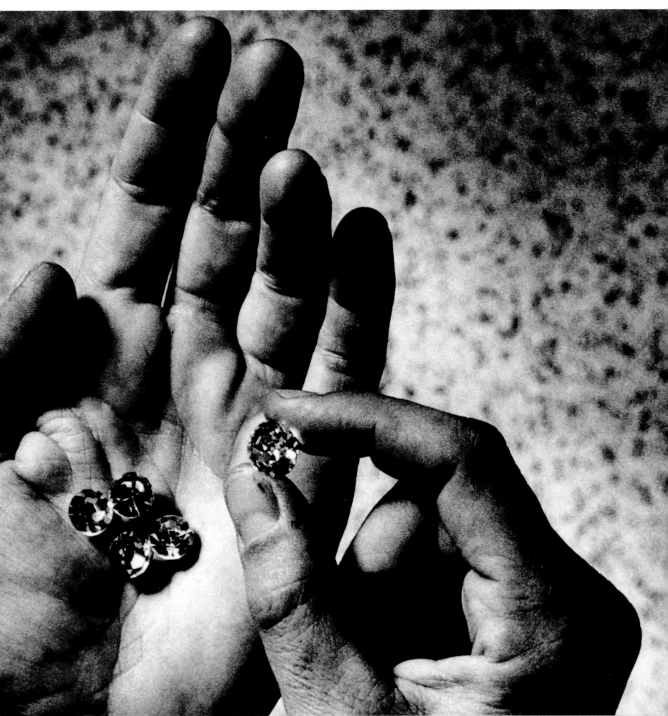

BRASS BATH

photographer **Steve Speller**

client	Philippa Brook
use	Editorial
assistant	Alison Milner
art director	Philippa Brook
camera	35mm
lens	24mm
film	Agfapan 400
exposure	1/60 second at f/16
lighting	Available light and electronic flash

Because the bath subject was such an other-worldly object, it was decided to photograph it somewhere large and open but with an aquatic connection.

plan view

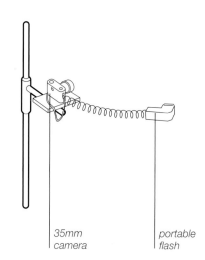

| 35mm | portable |
| camera | flash |

key points

Beware of tide when working on beaches

Salt water is extremely damaging to photographic equipment. If you accidently drop your camera in salt water, dip it immediately in fresh water to counter the effect

"I also like the fact that it looks a little like a Viking ship washed up on a beach," comments photographer Steve Speller. The curved prow, the mast-like shower head and deep hull certainly do have that resonance, and the bath looks perfectly at home in this stunning location. The low tide beach at Camber Sands in the UK provided miles of rippled sand behind the subject as a background, puddles of sea water for reflections, and a grey brooding skyline beyond.

The illumination is mostly natural daylight on this cloudy day, giving an overall soft diffused light. A small amount of fill-in flash was used to raise the subject and set it off against the background.

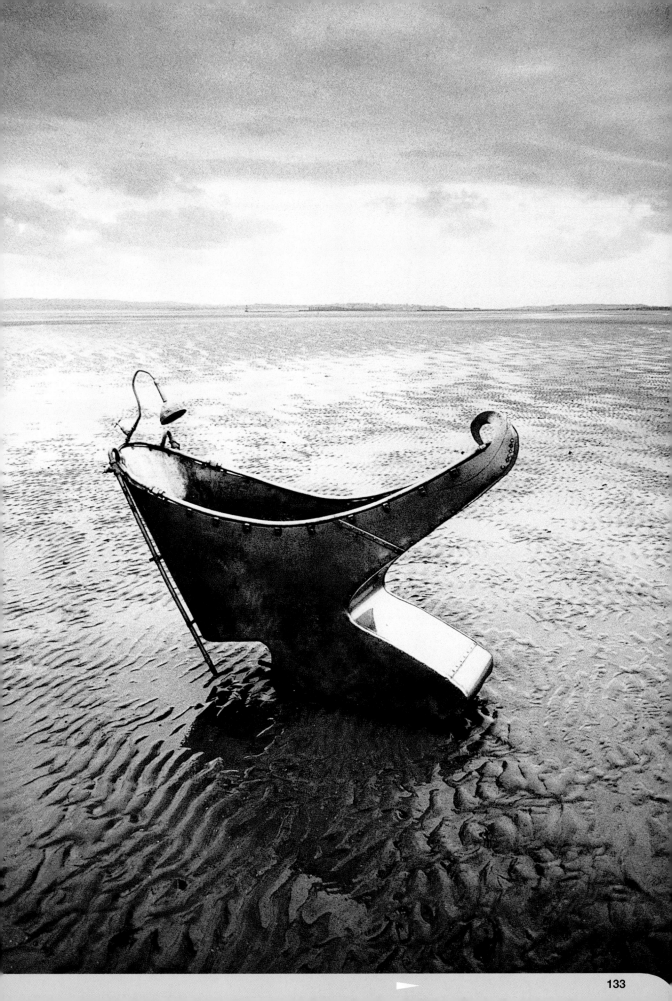

TONES, TINTS and
EFFECTS

07

There are many different photographic dyes and toners on the market for photographers to experiment with. Sepia and selenium are the most common, although a whole range of colours can be introduced, not just brown and blue. Another way of introducing a tone is to use specially prepared papers with a coloured base rather than just a white one or a warm-tone paper. Hand tinting can be applied to any photographic paper, even after toning. Through experience, the individual photographer may find certain paper finishes preferable to others.

It is important to consider which parts of the image are to receive the tints or tones, and to create appropriate areas of light and dark accordingly. While tints are applied by hand to specific – usually light – areas, tones affect the whole area of the image and may work best on predominantly dark-area images – depending of course on the look required. Whatever the case, the lighting can be planned with this in mind, to deliver the kind of light/dark surfaces needed.

KITON

photographer **Salvio Parisi**

client	Kiton Menswear
use	Advertising campaign
assistant	Chicca Fusco
art director	Salvio Parisi
camera	4x5 inch
lens	150mm
film	Tmax 100
exposure	1/125 second at f/11
lighting	Tungsten
props and background	White paper background

The top half of this interesting composition taken alone is essentially a graphic abstract; the lower part is a detailed, branded product shot.

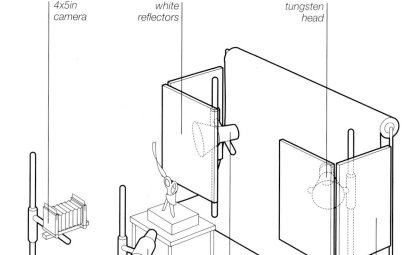

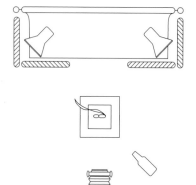

plan view

key points

A well-executed mixture of silhouette areas with lit details makes for an eye-catching combination of textures

Fishing wire serves well as an invisible thread for supporting props

In order to achieve the two distinct looks – the virtual silhouette of the scissors combined with the frontal-lit detailed image of the name tags – two distinct areas of lighting have been employed. The props are mounted on a block on a table top, with the tape suspended by fine thread.

Salvio Parisi explains: "To light this set, I've used a white paper background with two reflected tungsten heads at the sides to give a black silhouette of the scissors. One small spot light at the front, a tungsten spot snooted with a black paper cone, lights the tape of the suit company name tags."

Notice, however, that the 'silhouette' of the scissors is not absolute; slight highlights have been allowed to add just a little definition to the curvature.

photographer's comment

In accordance with the notion of Kiton hand-made men's suits, I photographed the silhouette of an old pair of scissors, with a tape of tags wrapped around.

ANDREW MAIN

photographer **Antonio Traza**

client	La Fotographica
use	Editorial
model	Andrew Main
art director	Antonio Traza
camera	6x9cm
lens	150mm
film	Polaroid 665
exposure	Not recorded
lighting	Electronic flash

"This shot was done for the magazine La Fotographica. It was a series on the best black and white printers in London," explains Antonio Traza.

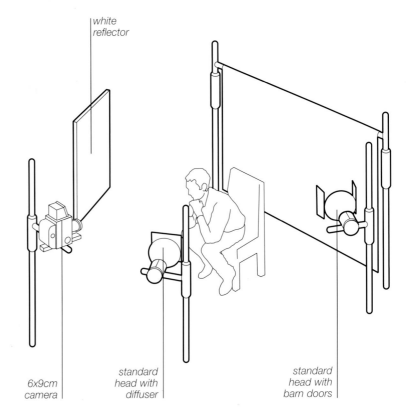

white reflector

standard head with diffuser

standard head with barn doors

6x9cm camera

plan view

key points

Polaroid 665 gives a negative as well as a positive image

Lighting and printing go hand in hand. A fairly even density negative gives the printer considerable latitude for creative input

"The idea was to photograph them and give them the negative so they could print in the style they thought was correct for their personality. For this particular one, the printer decided to print the portrait of himself on lith paper. In the article there was a description below the photograph with all the details of the printing process so readers could choose the printing they liked best and call the printer's studio for further details."

Two Norman 400-watt flash heads were used; one for the background and one for the subject. The reflector provides fill to ensure that there will be some detail on the face. The result is a shot with areas of bold, contrasting light and dark, graduated detail on the face and hair, and a range of in-between tones in the background; an excellent range of challenging features to enable a printer to show off his art.

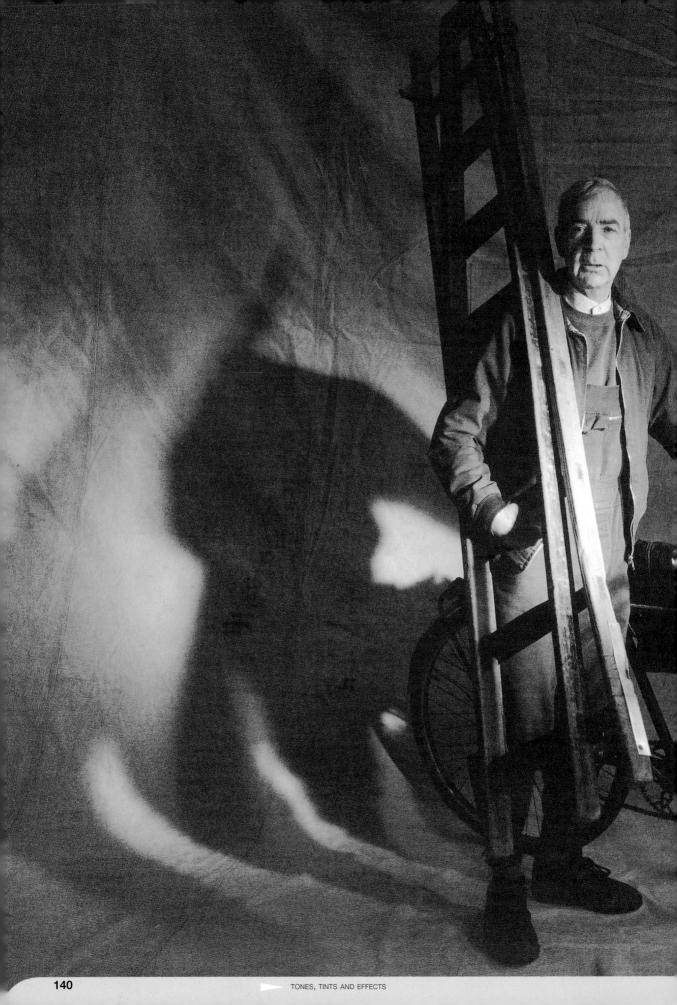

TONES, TINTS AND EFFECTS

ERNIE THE WINDOW CLEANER

photographer **Tim Ridley**

client	The Image Bank
use	Stock
model	Ernie
camera	6x7cm
lens	65mm
film	Ilford FP4
exposure	1/125 second at f/5.6
lighting	Tungsten

It is tempting to say that there are three models in a row in this shot: Ernie, to the right, his hard shadow in the centre of the row, and his soft shadow to the left.

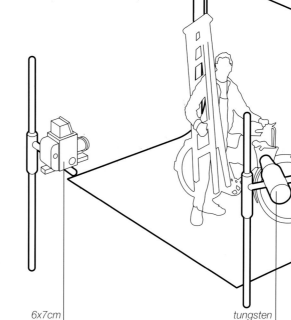

6x7cm camera tungsten spot tungsten head

plan view

key points

A crescent of relatively directional lights can be used to give a row of discrete shadows

Areas of light on a backdrop can be created either by paint or by lighting

The two lights to camera right are positioned to create this carefully placed series of figures. The light furthest from the camera is directed at the background and is set to flood, thus producing the less-defined soft shadow at the left of the composition.

The sharper shadow in the centre of the 'row' is produced by the second light, set to spot and positioned closer to the camera. This light is aimed directly at the model but it also picks up the near-side handlebar and provides a well-defined pool of light on the central area of the ladder.

SISTERS

photographer **Ray Spence**

The famous painting 'Gabrielle d'Estrees and Her Sister, the Duchess of Villars' by an artist from the Fontainebleau School is revisited and reworked here by Ray Spence, with just a touch of the Venus de Milo thrown in for good measure!

use	Exhibition
camera	6x7cm
lens	90mm
film	Ilford FP4
exposure	1/15 second at f/5.6
lighting	Tungsten
props and background	Black background

6x7cm camera

soft box

plan view

In the oil painting from the late 16th century, the nipple-pinching sisters are portrayed complete with heads and a full complement of limbs. Here, however, Ray Spence has chosen to make a famously obscure subject all the more unusual by reducing the figures to statue-like torsos with cropped limbs, and by creating a sculptural rather than painterly (or even photographic) surface texture.

The models were draped in black to eliminate the head and limbs as required, and a single soft box to camera right was used. The finishing consisted of printing through a textured mask to achieve the crumpled paper or crazed-glaze effect. The image was finally bleached, and the background sepia-toned.

key points

The combination of sepia-toning and texture-distressing gives an antiquarian feel to the image

Separately acquired elements of an image can be assembled either in the darkroom or digitally

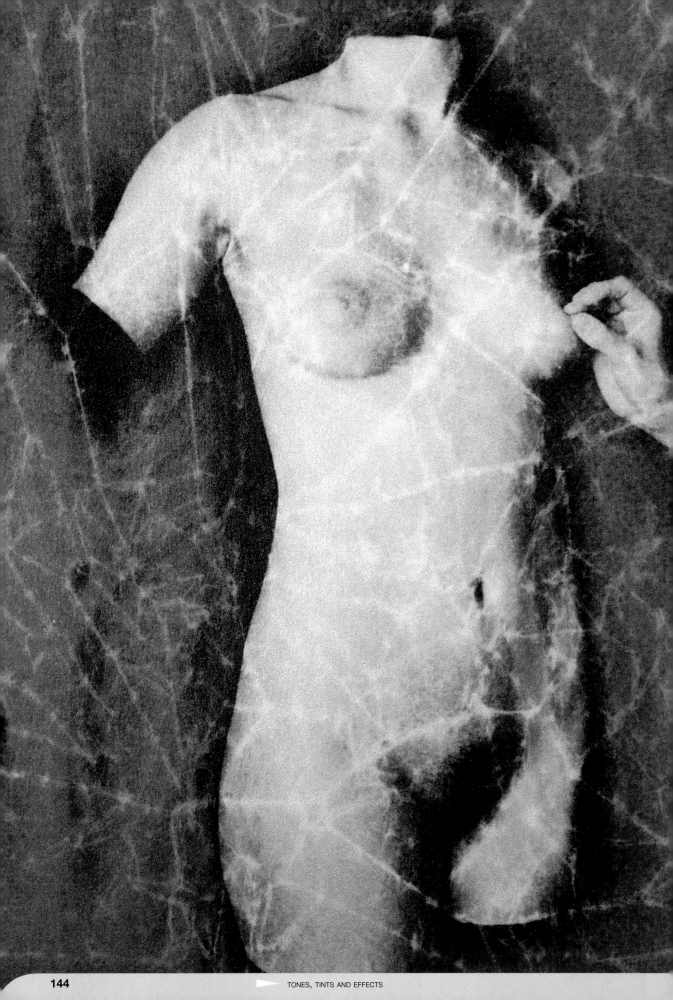

TONES, TINTS AND EFFECTS

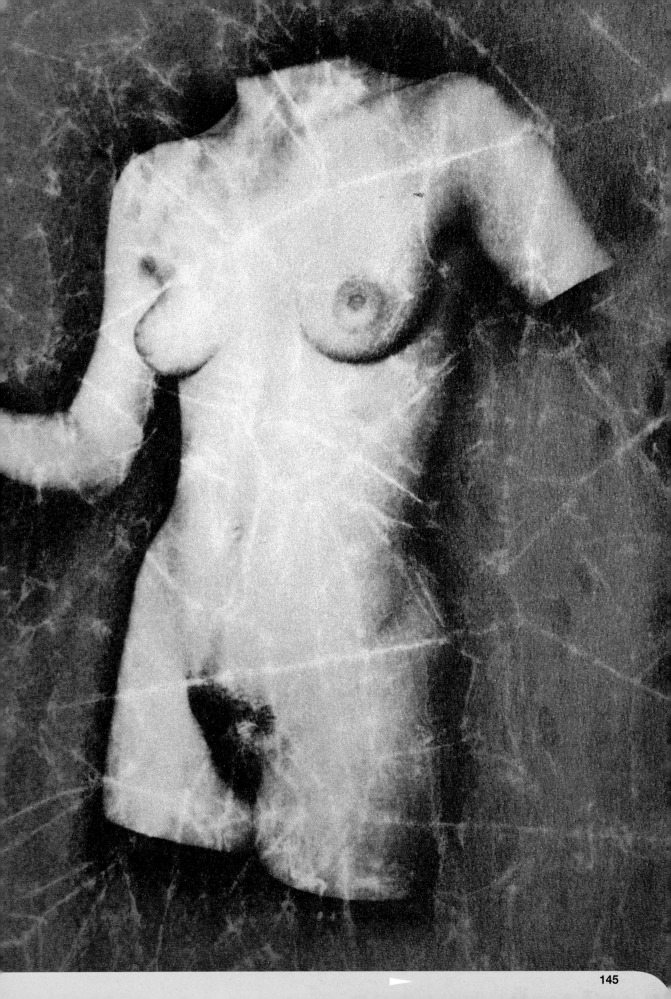

IRON EYES CODY

photographer **Ron P. Jaffe**

use	Editorial
model	Iron Eyes Cody
camera	35mm
lens	50mm
film	Kodak Tri-X
exposure	1/125 second at f/8
lighting	Tungsten
props and background	Black seamless background

One could be forgiven for thinking that this is a historical photograph from the early years of photography, but it is in fact the work of a contemporary photographer, evidently choosing to work within a well-established style.

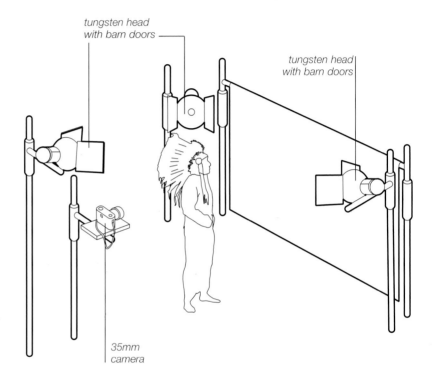

tungsten head with barn doors

tungsten head with barn doors

35mm camera

plan view

key points

Hard lighting generally gives a theatrical look

Although the light is hard, the overall modelling is reduced by the fact that it is all-round lighting

The warm tone, tending towards sepia, makes a large contribution towards the evocative resonances of this shot. But the direct hard lighting also has its part to play.

The 500-watt tungsten heads with barn doors are set in a triangle, all aimed at the subject in the centre. One of the lights is directly above and slightly behind the camera at a height of about seven feet. The other two are behind the subject at 45°, approximately at the level of the headdress. They illuminate the splendid facial profile and backlight the headdress, making the feathers glow.

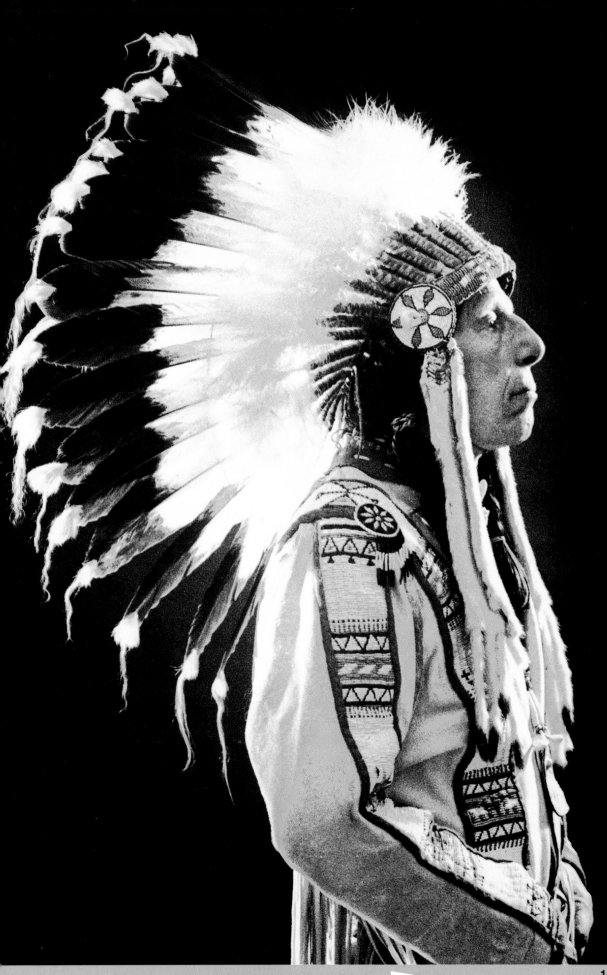

MERETE

photographer **Björn Thomassen**

use	Model portfolio
model	Merete
camera	645
lens	100mm
film	Tmax 100
exposure	1/250 second at f/8
lighting	Electronic flash

The flawless complexion of this model has the look of finest porcelain. The skin on the arms, for example, has a smooth, pearly and almost iridescent glow.

soft box tri-flector

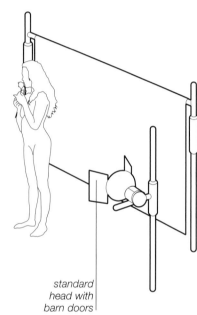

645
camera

standard
head with
barn doors

plan view

key points

Stockings of different thickness and colours can give interesting results when used over the lens as a filter

With an overall smooth pale look for the subject, it is important to compose and light for some rim definition of the shapes to gain enough separation and modelling

Apart from the model's own natural assets providing a first-rate subject, this look is the result of extremely sensitive lighting combined with further flattering softening of the light by means of a 15-denier black net stocking over the lens.

The main lighting was a soft box to camera left with a tri-flector just out of shot below the soft box. The sliver of light along the back and the edge of the

arm comes from a side-lighting standard head with barn doors on the opposite side.

The gentle shadowy halo behind the subject was created at the printing stage by holding back the selected areas just around the model, while the edges of the frame were allowed to register light.

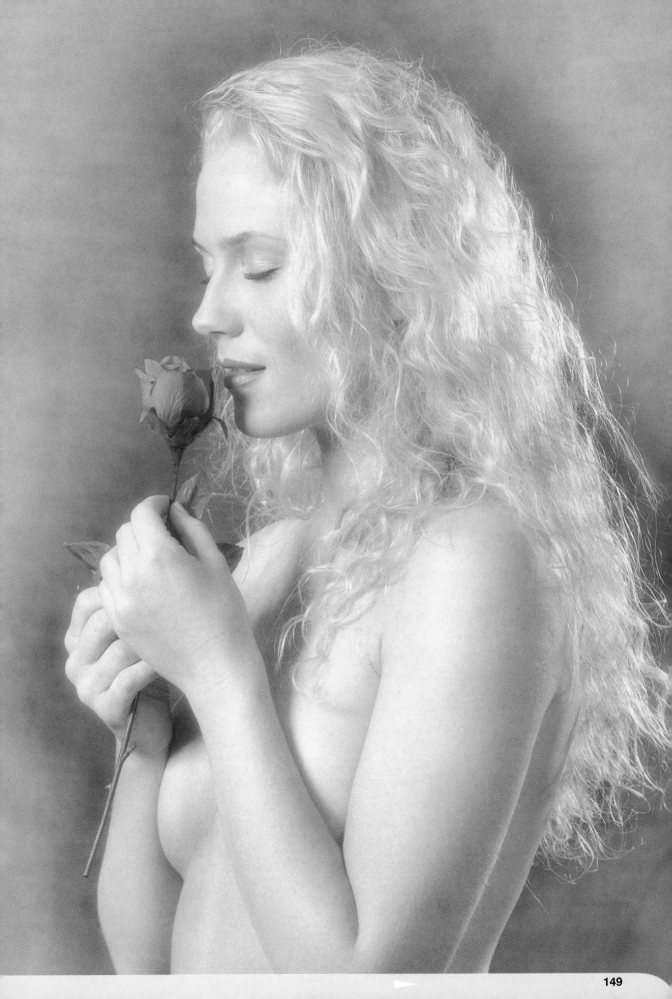

SANDRA

photographer **Björn Thomassen**

client	Sandra
use	Model portfolio
camera	645
lens	100mm
film	Tmax 400
exposure	1/60 second at f/8
lighting	Available light
props and	
background	Disused warehouse

The location was the exterior of a disused warehouse so the main light source was the ambient daylight.

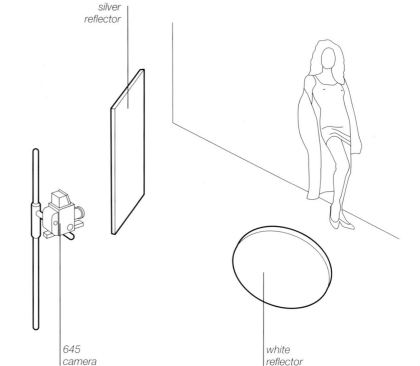

silver reflector

645 camera

white reflector

plan view

key points

White reflectors give a relatively dispersed quality of light

Silver reflectors give a relatively hard and more directional quality of light

The direction of this available light was modified by the exact choice of site for the shoot. By positioning the model beneath a projecting area of tin roof, directional light from above was blocked off so the remaining light amounted to soft ambient sources from either side.

This was modified further by the use of a silver foil reflector to camera left and a white reflector to camera right. The white reflector is effectively keying on the right side of the image because of its closer proximity.

The hand-tinting of the dress provides the finishing touch. Kodak photographic dyes and a very steady hand were used!

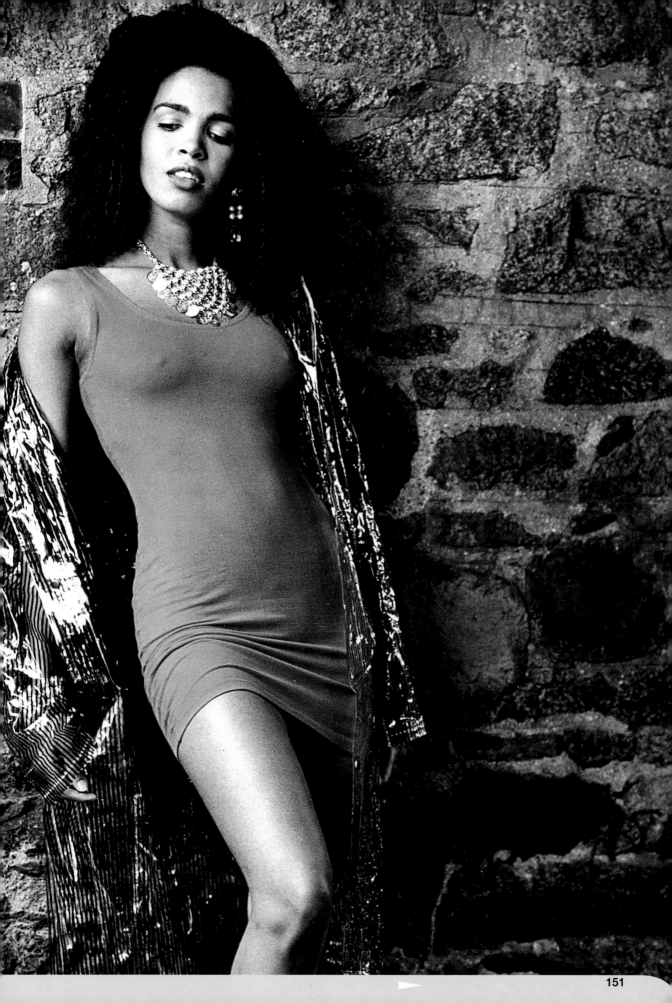

TONIA BUXTON

photographer **Ronnie Bennett**

client	Tonia Buxton
model	Tonia Buxton
camera	645
lens	150mm
film	Kodak Tri-X
exposure	1/60 second at f/16
lighting	Electronic flash

The serene calmness of the subject is complemented by the graphic simplicity of the composition and lighting.

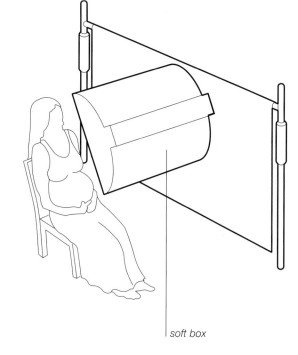

plan view

645
camera

soft box

key points

Lith printing is particularly effective with a high contrast negative and a medium-toned background

Combine graphic patterns of props, clothing and pose with a graphic composition for a bold, strong look

Ronnie Bennett frequently enjoys setting up a structure of vertical and horizontal elements; provided in this case by the chair, to which she adds a strong diagonal, provided by the pose of the model. The zig-zag pattern on the clothing plays further with the bold linear design of the shot.

It is interesting to compare the lighting effect here with that of Ron P. Jaffe's shot, "Iron Eyes Cody".

"Iron Eyes Cody" is lit with hard light but gives a soft look, while this Ronnie Bennett shot is lit with soft light (a single soft box) but yet produces a hard graphic look. The difference is to do with the presence or absence of fill, as well as the finishing. The lith printing technique used by Ronnie Bennett increases the contrast of the overall image.

photographer's comment

I shot this picture to be lith-printed, as I felt that Tonia's pregnant shape and sleek hair would make a particularly strong graphic image.

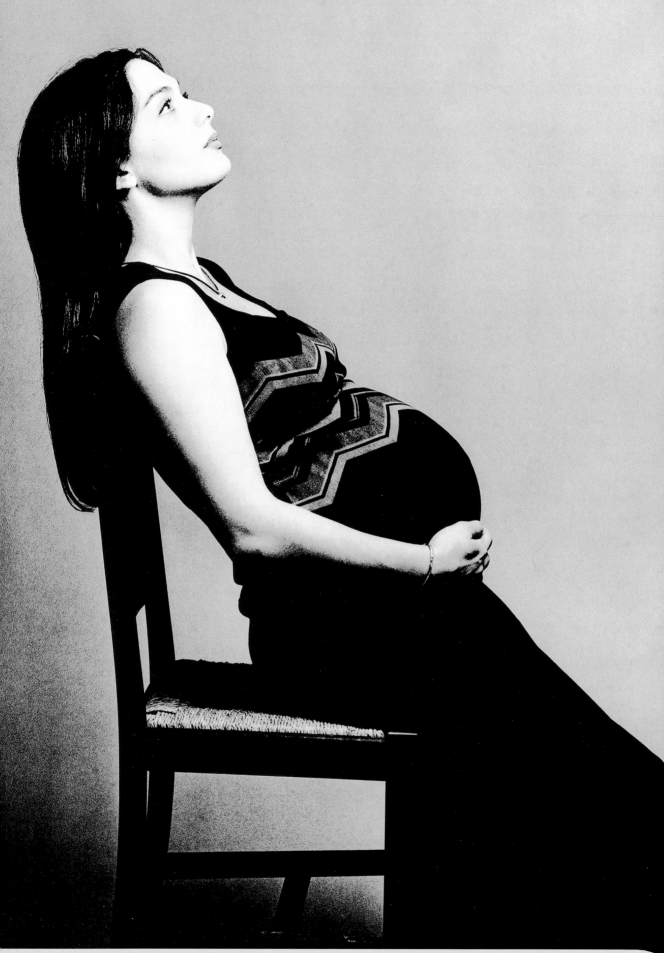

DIRECTORY of
PHOTOGRAPHERS

08

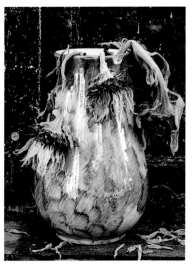

photographer	**Robert Anderson**
address	RAP Productions
	1230-A East Jackson Street
	Phoenix
	Arizona 85034
	USA
telephone	+1 602 254 8178
fax	+1 602 256 2796
email	randerson@uswest.net
agent	Rhoni Epstein
	Rhoni Epstein Artists'
management	11977 Kiowa Avenue
	No.307
	Los Angeles
	CA 90049
	USA
biography	Robert Anderson is widely known for his provocative fashion and advertising imagery. Primarily self-taught, his unique style reflects strong vision and a personal pursuit of technical mastery. After six years in corporate photography, Robert established his own studio in the American Southwest where he is inspired daily by the diverse exotic locations so close to his door. His client list includes national and international corporations, ad agencies, record companies and magazines. Increasingly, Robert is commissioned to do celebrity and advertising portraiture.

p: 125

photographer	**Ronnie Bennett**
address	Portridge House
	Old Burghclere
	Newbury
	Berkshire
	RG20 9NH
	England
telephone	+44 (0)1635 278517
fax	+44 (0)1635 278710
biography	Ronnie Bennett began her career as a portrait photographer just four years ago after completing a City & Guilds Professional Photography course. Since then she has won over 30 awards, including a Fellowship with the Royal Photographic Society, a Kodak European Gold Award for Portraiture and the Fujifilm Portrait Photographer of the Year. Ronnie's technique combines a dynamic view of composition, a sensitive eye for light and a profound interest in her subjects. Over

the last four years she has worked mainly for private clients, but she is planning to diversify her work and move sideways into advertising and magazine illustration.

pp: 29, 37, 39, 153

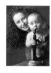

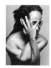

photographer	**Annella Birkett**
address	12 Delves Way
	Ringmer
	East Sussex
	BN8 5JU
	England
telephone	+44 (0)1273 812813
biography	A fine art monochrome enthusiast, Annella Birkett is a Fellow of the Royal Photographic Society and has sat on their pictorial assessment panel. She has a BA in Photography from PCL. In addition to her photographic work, Annella has found time to study life-drawing and sculpture and is currently undertaking a degree in Art History. She feels that academic study has given her an understanding of photographic theory and the use of colour, and also raised her awareness of digital imagery's potential. Her interests are polarised between the total control of studio still life – resulting in a 'straight print' – and the 'psychological' portrait that uses digital techniques.

pp: 95, 97

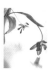

photographer	**Guido Paterno Castello**
address	GPC Studio
	Avenida Henrique Dodsworth
	83/1005
	Rio de Janeiro
	Brazil
telephone	+55 21 2870789
	or +55 21 2743859
fax	+55 21 5221064
email	imadv@mbox.vol.it
biography	Born in New York in 1958,

Guido Paterno Castello moved to Paris to study art and now lives and works in Rio de Janeiro. He has won numerous awards for his work, including a Gold Medal from the Brazilian Association of Marketing and Advertising (ABRACOM). Most of Guido's clients are major agencies based in his home city.

p: 41

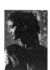

photographer	**Gerry Coe**
address	Lasting Image
	667 Lisburn Road
	Belfast
	BT9 7GT
	Northern Ireland
telephone	+44 (0)1232 668001
fax	+44 (0)1232 668001
biography	Gerry Coe is the 1998/99 AGFA Photographer of the Year. He has achieved Fellowship at the British Institute of Photographers and was given the Peter Grugeon Award for Best Fellowship Panel.

pp: 33, 35

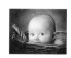
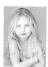

photographer	**David John Correia**
address	Images by David John Correia
	21 Pershing Road
	Jamaica Plain
	USA
telephone	+1 617 524 3444
	or +1 781 878 7373
website	www.davidphoto.com
biography	David John Correia graduated from Boston University in 1981 with degrees in Photojournalism and French Language and Literature. His studio work includes portraiture, fashion and art illustration and he runs a wedding photography company that services weddings across New England. David is influenced by Henri Cartier-Bresson, Richard Avedon and Paul Strand, as well as by his own life experiences and the books he reads. He is a member of the 4th Floor Artists for which he also serves as a board member.

His art work is represented by the Charles-Baltivak Gallery in Provincetown and the Crystal Art Gallery in Boston.
pp: 31, 49

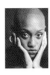

photographer	**Juan delGado**
address	38 Fifth Avenue
	London
	W10 4DN
	England
telephone	+44 (0)208 968 6334
fax	+44 (0)208 968 6334
email	postmaster@delgado.u-net.com
biography	Born in Cartagena in 1965, Juan delGado studied photography and design at the Escola D'Arts I Oficis de Valencia. He moved to London in 1994 to study Contemporary Media at the University of Westminster and has exhibited mainly in England and Spain ever since. In England his work has been shown at the Royal Festival Hall, the National Portrait Gallery, the Royal Society of Photography and the Museum of Film and Television. He has been involved in the experimental films, 'Toccata et Fugue'(1997), 'The Passion of Teresa'(1998) and the documentary 'Breaking Mirrors'(1999), and in 1997 he was selected for the John Kobal Photographic Portrait Award. He currently works as a freelancer, specialising in portraiture.

pp: 23, 65, 69

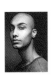 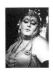

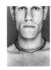

photographer	**Wolfgang Freithof**
address	Wolfgang Freithof Studio
	342 West 89th Street Suite 3
	New York 10024
	USA
telephone	+1 212 724 1790
	or +1 917 774 1738
fax	+1 212 580 2498

website	www.wfx.net
biography	New York-based freelancer Wolfgang Freithof has an international client base and covers a wide range of assignments. He specialises in fashion, portrait, advertising and record covers, as well as fine art.

p: 107

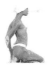

photographer	**Kathleen Harcom ARPS**
address	Forest View
	Furzey Lodge
	Beaulieu
	Hants SO42 7WB
	England
telephone	+44 (0)1590 612304
email	harcom_family@compuserve.com
biography	A black and white photography specialist, Kathleen Harcom concentrates mainly on landscapes. She aims to produce delicate, ethereal images with a timeless quality by using infrared film combined with lith printing and toning. Kathleen likes to print her work personally because it gives her precise control over the final image. She is an Arena member and Associate of the Royal Photographic Society. As well as writing articles for Practical Photography, she has had pictures published in Creative Monochrome Books and several magazines.

pp: 55, 91

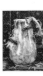 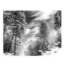

photographer	**Caroline Hyman**
address	Caroline Hyman Photography
	Stud Farm House
	Skirmett
	Henley-on-Thames
	Oxon RG9 6TD
	England
telephone	+44 (0)1491 638321
fax	+44 (0)1491 638829
biography	Caroline Hyman began her career as assistant to a top fashion photographer. She specialises in black and white-toned and hand-coloured limited edition photographs and prints her

own work. Caroline's subjects are mainly found close to home in the countryside surrounding her farmhouse, but she also makes good use of trips abroad. She has won numerous photography awards and was recently described by leading British photographer, Terry O'Neil, as "the Georgia O'Keefe of the camera". She is a Fellow of the Royal Photographic Society, a member of Arena and is represented by Focus Gallery in London.

p: 89

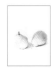

photographer	**Ron. P. Jaffe**
address	Ron P. Jaffe Photography
	6200 Vista del Mar ste. 205
	Playa del Ray
	California 90293
	USA
telephone	+1 310 822 0386
email	RPJphotog@aol.com
biography	In twenty-three years Ron P. Jaffe has travelled to over thirty countries and photographed the likes of Ronald Reagan and Henry Kissinger. He is comfortable working with everyone: from suit-wearing professionals to Hollywood celebrities and leading political figures. Ron's photography experience includes glamour, fashion and location, and he has conducted over thirty-thousand portrait sessions. Able to set up and establish photo shoots on a minimum notice, Ron's quick intuition and casual approach to subject really allow him to capture mood and emotion. He has exceptional ability in manipulating light and often uses old Hollywood 'high-key' lighting effects in his work.

pp: 147

photographer Saulo Kainuma
address R. Caetete, 129
Rio Vermelho
Salvador
Bahia 40225-000
Brazil
telephone +55 71 346 4355
fax +55 71 346 4354
p: 58

photographer Ben Lagunas and
Alex Kuri
address BLAK PRODUCTIONS
Galeana 214 Suite 103
Toluca CP 50000
Mexico
telephone +52 72 15 90 93
or +52 72 17 06 57
fax +52 72 15 90 93
biography Ben and Alex studied in the
USA and are now based in
Mexico. They are both Master
Instructors at the Kodak
Educational Excellence
Centre and their work takes
them around the world. Their
client base includes
advertising agencies, record
companies, magazines,
artists and celebrities, as well
as direct clients. Ben and
Alex's editorial work has
appeared in international
magazines and their fine art
photography is regularly
exhibited in galleries. Their
work can also be seen in
The Art Director's Index
(RotoVision), 'Greatest
Advertising Photographers of
Mexico' (Kodak) and in the
RotoVision ProLighting Series
('Nudes', 'Portraits', 'Still
Life', 'Night Shots', 'New
Glamour Shots', 'Beauty
Shots', 'Fashion Shots', 'New
Product Shots' and 'Erotica').
BLAK PRODUCTIONS
provide a full production
service that includes casting,
scouting and models.
pp: 105, 109, 114

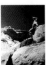

photographer Salvio Parisi
address Via Miliscola 2a trav.,
(Naples) 31 Arco Felice
Napoli 80072
Italy
telephone +39 081 8663553
fax +39 081 5267502
address Via XX Settembre
(Milan) 127 Sesto S. Giovanni
Milano 20099
Italy
telephone +39 02 24472559
address Via Di San Crisogono, 40
(Rome) Roma 00153
Italy
telephone +39 03 36694739
biography Salvio Parisi considers it
essential to represent the 'job
fiction' through his style, as
well as respecting the
philosophy and ideas of the
client. Taking those two rules,
Salvio uses fundamental
instruments – such as a
planning schedule – to
achieve technical precision
and a final aesthetic effect.
He believes in a professional
working system.
pp: 121, 127, 137

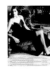 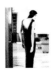

photographer Tim Ridley
address Tim Ridley Photography
70–71 Wells Street
London W1P 3RD
England
telephone +44 (0)207 580 5198
fax +44 (0)207 323 3690
biography A self-taught photographer,
Tim Ridley started his career
learning printing as a
darkroom assistant. He went
on to work with various
professional photographers
and now runs his own studio
in London. He has worked in
publishing, PR and
advertising, and has also
supplied images to photo
libraries. Tim's heart lies in
black and white reportage
and darkroom techniques,
and he increasingly uses
electronic manipulation in his
work. His influences are the
painters Dali and Hopper, as
well as the photographers
Lee Friedlander, Joel
Meyerowitz and Ernst Haas.
Tim's portrait of Auberon

Waugh was included in the
1999 John Kobal Portrait
Award.
pp: 21, 61, 93, 140

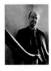 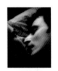

photographer Gianni Russo
studio GFR Studio Fashion and
(office) Advertising Photography
Pod Parukarkou 2760/14
13000
Prague 3
Czech Republic
address Dalimilova 13
(office) 13000 Prague 3
Czech Republic
telephone +42 2 6975525
mobile 0603 347773
fax +42 2 6975525
biography Born in Italy in 1961, Gianni
Russo worked as a
photographer in his native
country before relocating his
studio to Prague. Gianni
specialises in portrait and
fashion photography and has
worked for advertising and
model agencies, as well as
fashion and beauty
magazines. His fine art
glamour work has been
shown in magazines and at
exhibitions.
p: 101

photographer Gérard de Saint-Maxent
address 10 rue de Vouille
75015 Paris
France
telephone +33 1 45 30 01 90x
biography Gérard de Saint-Maxent has
worked in advertising and
publicity since 1970. He
specialises in black and
white photography.
pp: 45, 131

photographer Dima Smelyantsev
address 1111 River Road No. B27
Edgewater
New Jersey 07020
USA
telephone +1 201 224 4317
fax +1 201 224 4317
biography After living in Azerbaijan for most of his life, Dima Smelyantsev moved to New Jersey during the 1990 Armenian conflict. He has been passionate about photography since he was a young boy and his father bought him a Soviet FED-2 camera. Dima's interest in experimentation and "unsociable imagery" won him few friends in the ideologically correct Russia of the Cold War era. Now though, he has found a new home in New York's Synchronicity Space Gallery where he regularly exhibits.
pp: 19, 47

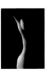

photographer Steven Speller
address 8 New Parade
Worthing
West Sussex BN11 2BQ
England
telephone +44 (0)1903 539119
mobile 0411 360091
fax +44 (0)1903 539119
biography A graduate of Bournemouth & Poole College of Art & Design, Stephen Speller worked in London for designers, record companies and magazines before moving to Worthing. He has always specialised in portraits, but since 1992 half of his commissions have been still life. Stephen continues to work mainly for London clients and has gained a reputation for his use of vibrant colour. He is influenced by "everything".
pp: 123, 129, 133

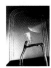
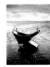

photographer Ray Spence
address 11 Headland Close
Welford-on-Avon
Warwickshire CV37 8EU
England
telephone +44 (0)1789 750195
biography Ray Spence is a fine art photographer and lecturer working mainly for exhibition and publication. He is the author of 'Form and Fantasy' and 'Beyond Monochrome' and his work is held in private collections across the UK, Europe and the USA. Ray is represented by The Special Photographer's Company and specialises in still life, natural forms and the body. He also offers unique alternative printing processes.
pp: 53, 75, 85, 117, 144

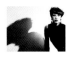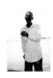
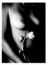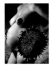

photographer Holly Stewart
address Holly Stewart Photography
370 Fourth Street
San Francisco
CA 94107
USA
telephone +1 415 777 1233
fax +1 415 777 2997
biography Holly Stewart has had a life-long fascination with finding and photographing objects. Her food and still life images reveal the simple yet extraordinary truth in objects of the everyday world. Since opening her studio in 1991 she has collaborated on editorial and commercial projects in print and on film, and has been involved in advertising campaigns for Gordon Biersch Beer, Sprint, Bank of America and Got Milk? Holly has worked for Esquire, Coastal Living and Appellation Magazine, and on three books. Her diverse portfolio includes everything from portraiture to product photography and she has won numerous awards.
pp: 27, 51, 71, 79

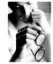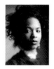

photographer Björn Thomassen
address 37 Boslowick Road
Falmouth
Cornwall TR11 4EZ
England
telephone +44 (0)1326 211343
fax +44 (0)1326 211343
biography Born in Cornwall Björn Thomassen moved to Scandinavia as a young boy. He became a professional photographer eleven years ago and is now back on the English south coast working out of his own studio. Bjorn has a Fellowship in Illustrative Photography and prefers the more artistic forms of contemporary portraiture.
pp: 81, 110, 149, 151

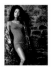
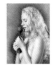

photographer Antonio Traza
address 8 St Paul's Avenue
London NW2 5SX
England
telephone +44 (0)208 459 7374
fax +44 (0)208 459 7374
biography Antonio Traza specialises in photography for advertising, editorial and design groups. His work includes portraiture, fashion and fine art.
pp: 25, 67, 73, 87, 103, 139

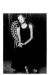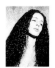
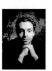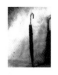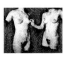

ACKNOWLEDGMENTS

First and foremost, many thanks to the photographers and their assistants who kindly shared their pictures, patiently supplied information and explained secrets, and generously responded with enthusiasm for the project. It would be invidious, not to say impossible, to single out individuals, since all have been helpful and professional, and a pleasure to work with.

We should like to thank the manufacturers who supplied the lighting equipment illustrated at the beginning of the book: Elinchrom, Photon Beard, Strobex, and Linhof and Professional Sales (importers of Hensel flash) as well as the other manufacturers who support and sponsor many of the photographers in this and other books.

Thanks also to Brian Morris – who devised the PRO-LIGHTING Series, Kate Noël-Paton, Zara Emerson, Simon Hennessey and Tina Bell.